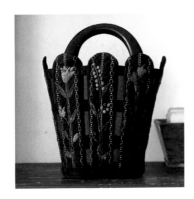

JAPANESE QUILTING
piece by piece

First published in the United States in 2012 by Interweave Press

INTERWEAVE.
interweave.com

Interweave Press LLC
201 East 4th Street
Loveland, CO 80537-5655 USA
interweave.com

Printed in China

10 9 8 7 6 5 4 3 2 1

MOTTO JIYU NI PATTERN WO KUZUSHITE MITARA – Yoko Saito's Patchwork
Copyright ©2006 by Yoko Saito
All rights reserved.
Publisher of the original Japanese edition: Sunao Onuma
Book design & layouts: Kayoko Wakayama, Asami Kuroda, L'espace
Photography: Yasuo Nagumo
Tracing: Shikano room

Original Japanese edition published by EDUCATIONAL FOUNDATION BUNKA GAKUEN
BUNKA PUBLISHING BUREAU.
English translation rights arranged with EDUCATIONAL FOUNDATION BUNKA GAKUEN
BUNKA PUBLISHING BUREAU through The English Agency (Japan) Ltd.
English-language rights, translation, and production by World Book Media, LLC
Email: info@worldbookmedia.com

Translated by Kyoko Matthews
English-language editor: Lindsay Fair

JAPANESE QUILTING
----- piece by piece -----

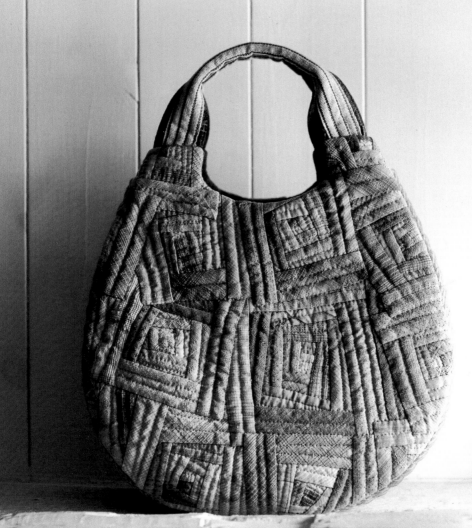

29 stitched projects from
YOKO SAITO

Contents

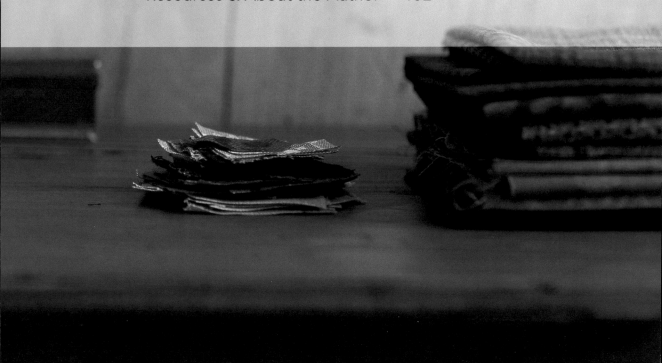

I've always loved traditional patchwork patterns. Knowing the history associated with a design provides me with a sense of comfort and makes the quilting experience more meaningful. Yet each time I started one of these quilts, I would struggle to make progress because I constantly had to stop and fix my imprecise angles and crooked seams. Full of frustration, I felt that there had to be a better way. Then it dawned on me: If I couldn't make perfectly even pieces, why not design quilts that were intentionally irregular? To my great surprise, I was more proud of the quilt I created that day than any of the painstakingly perfect ones that I had labored over. From that moment on, I preferred to incorporate unsymmetrical shapes into my appliqué and patchwork motifs. This new philosophy has opened my mind and allowed me to rediscover the joy of quilting. I hope this book inspires you to break free from convention and experiment with your favorite traditional patterns. Enjoy the experience and be proud of the truly unique works of art you create!

Yoko Saito

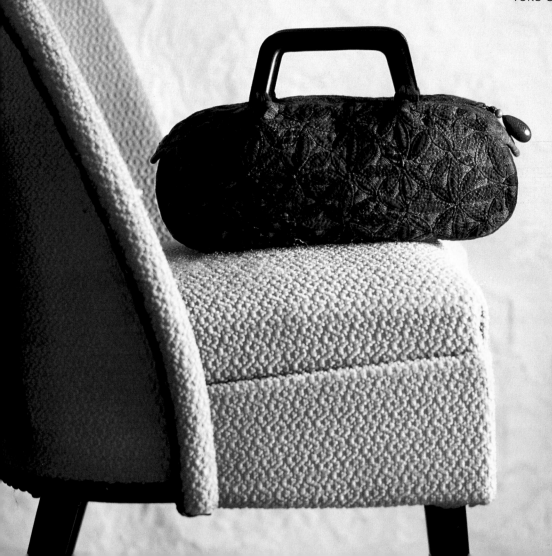

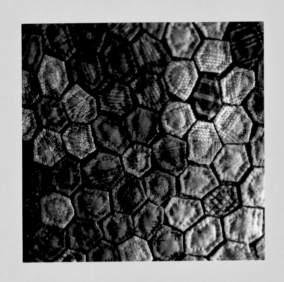

PART 1

The Projects

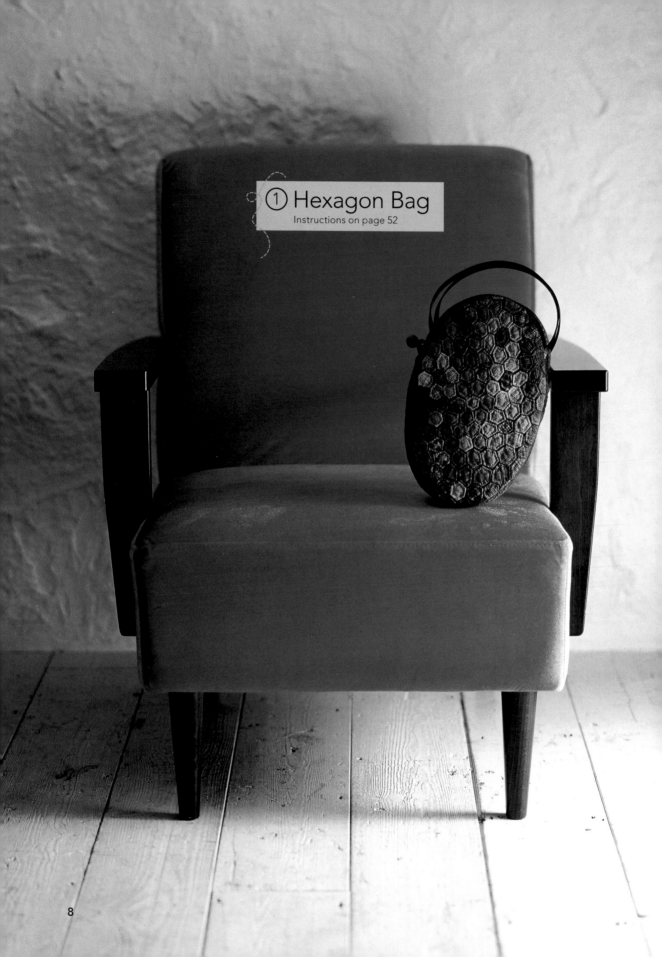

① Hexagon Bag
Instructions on page 52

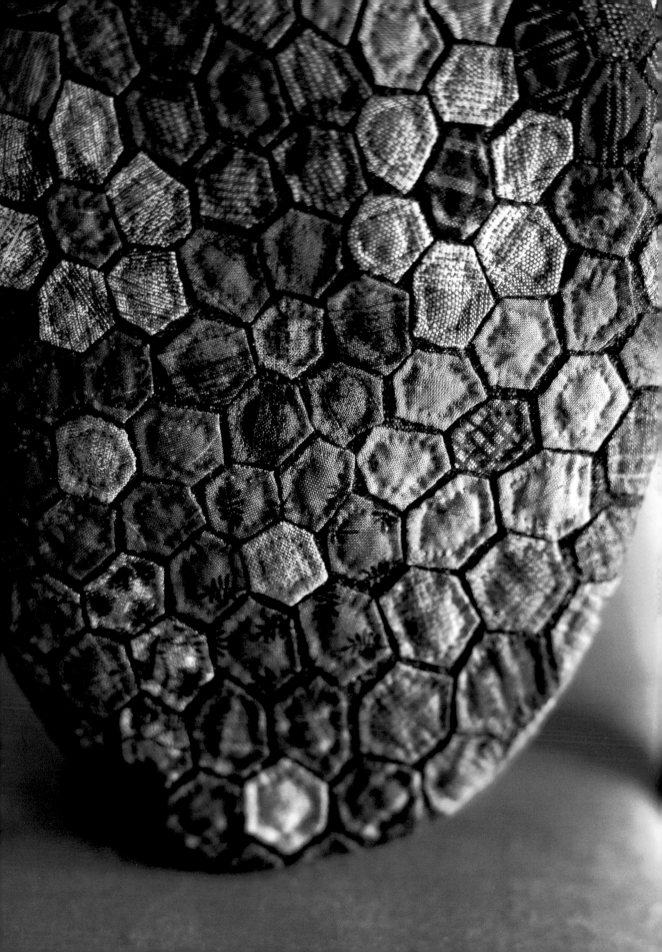

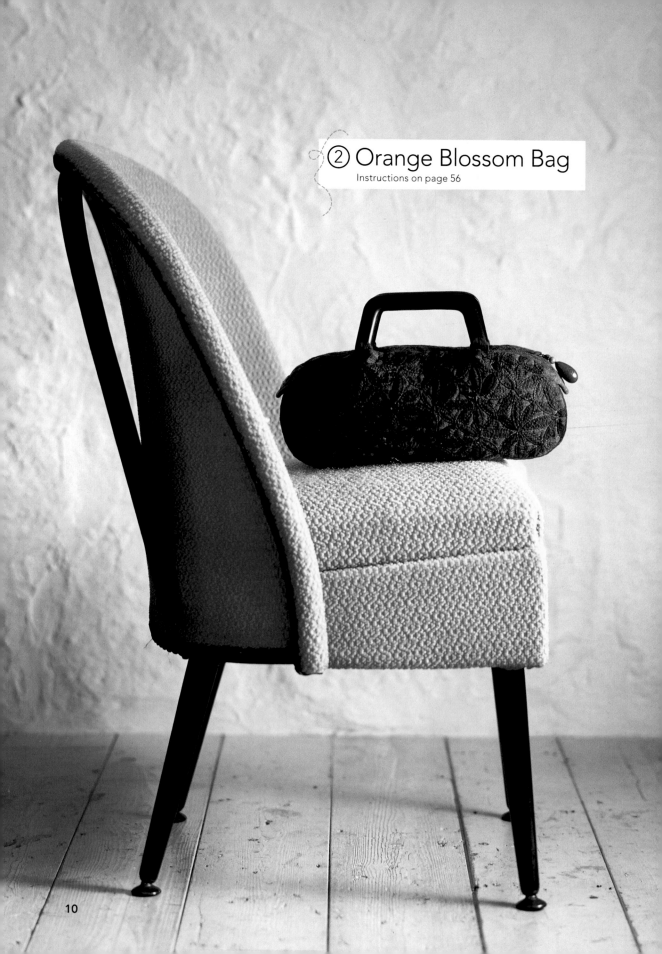

② Orange Blossom Bag
Instructions on page 56

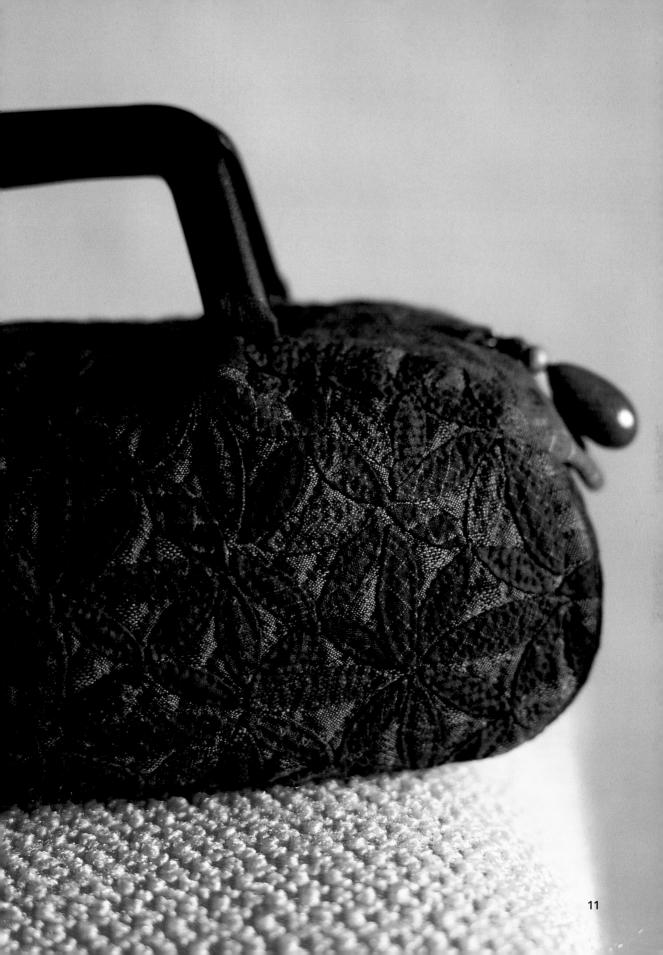

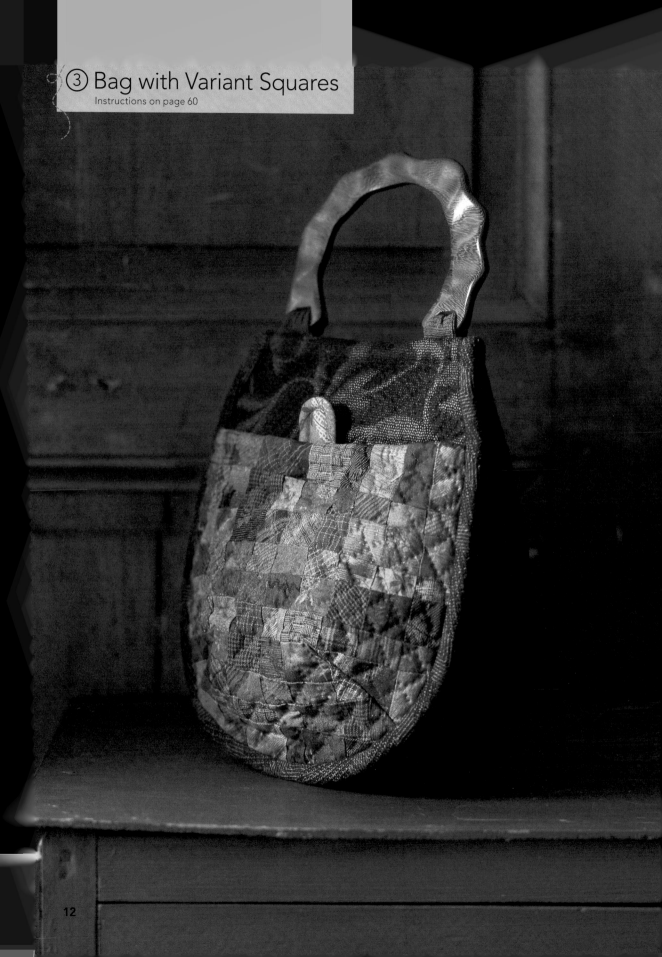

③ Bag with Variant Squares
Instructions on page 60

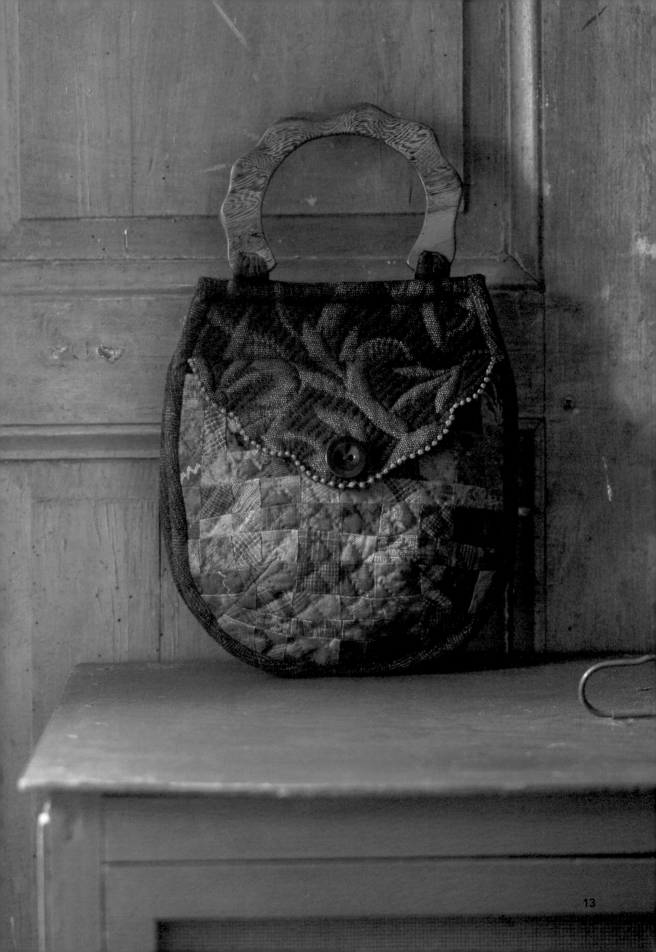

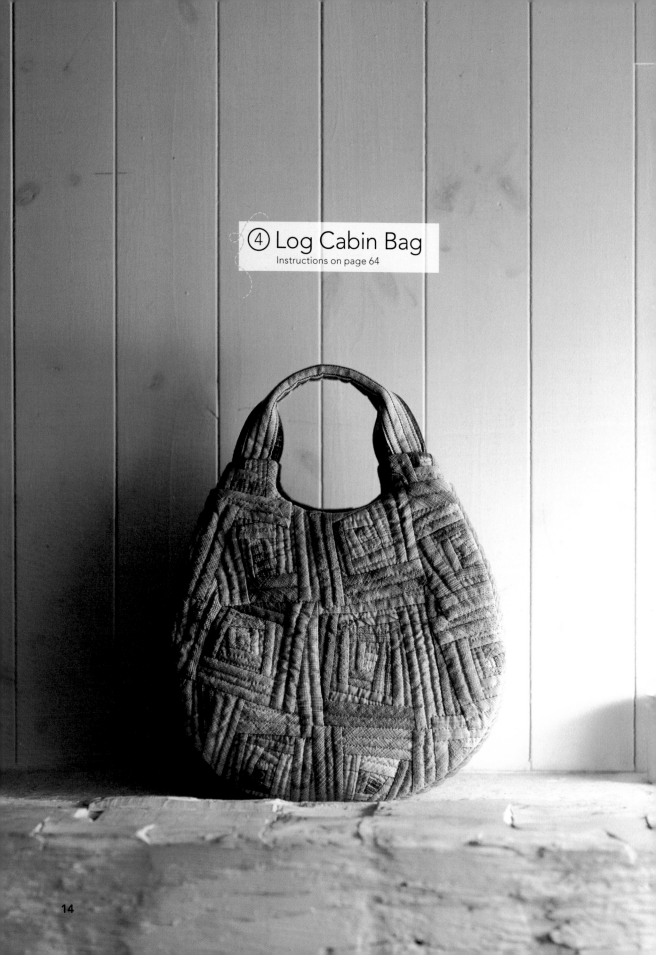

④ Log Cabin Bag
Instructions on page 64

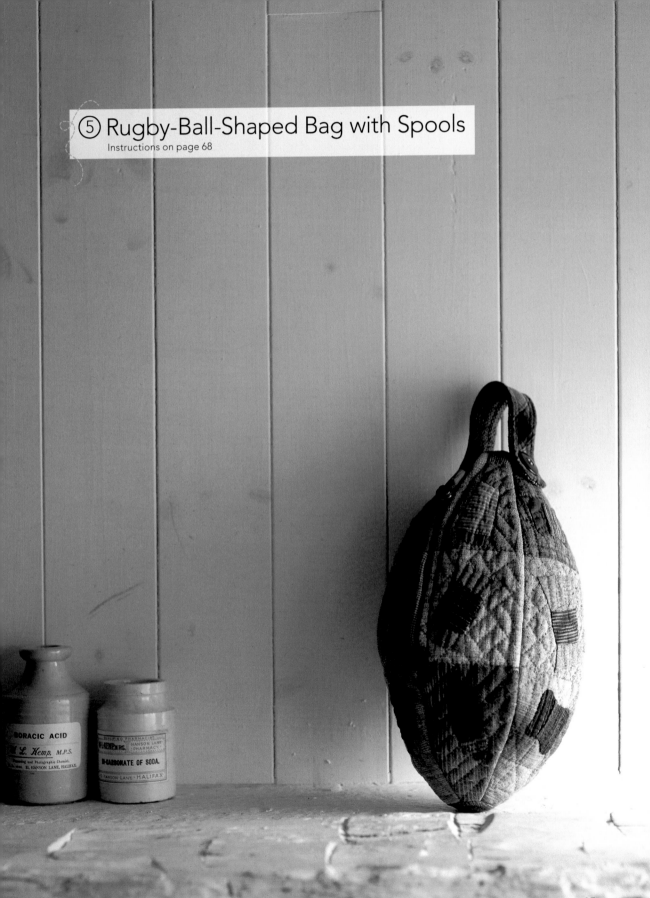

⑤ Rugby-Ball-Shaped Bag with Spools
Instructions on page 68

 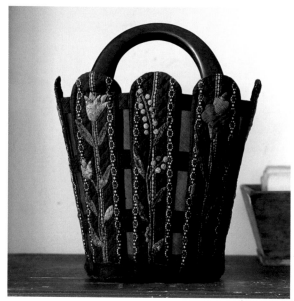

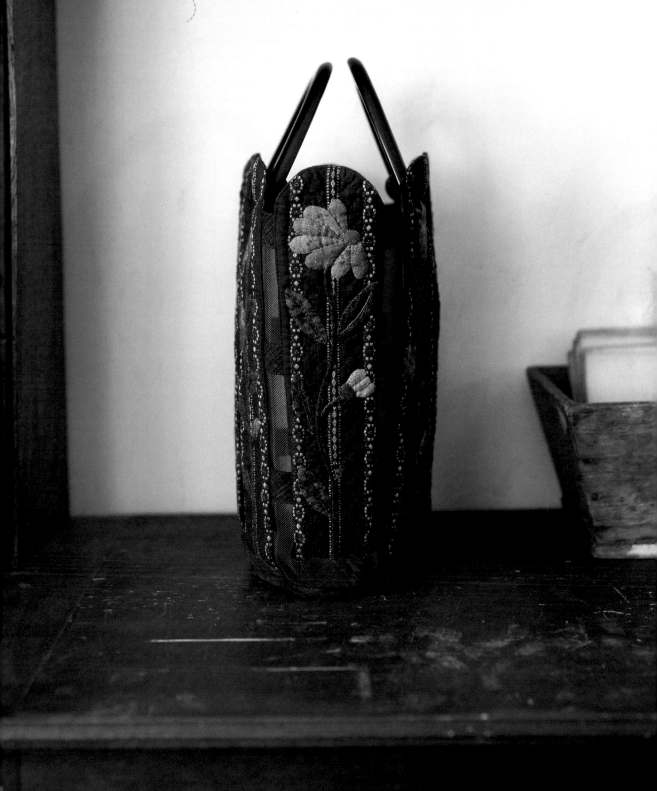

⑥ Basket with Flower Appliqué
Instructions on page 71

⑦ Trapezoidal Bag with New York Beauty

Instructions on page 75

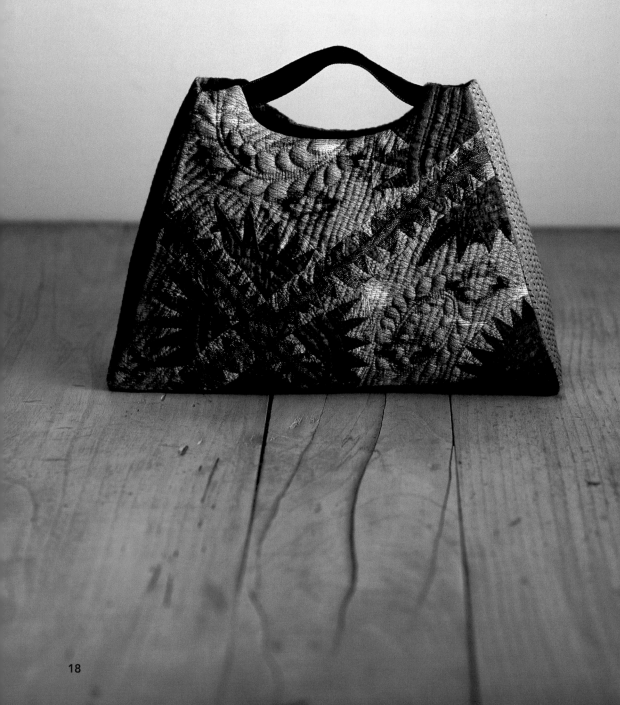

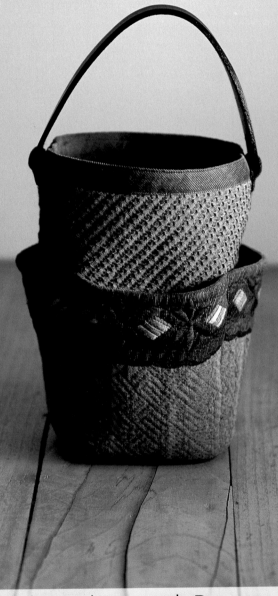

⑧ Bucket-Shaped Bag with Reverse Appliqué
Instructions on page 79

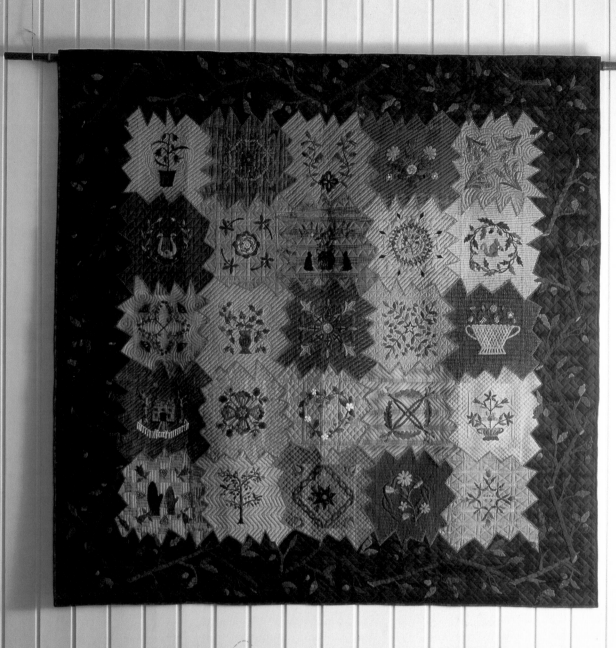

⑨ Baltimore Quilt
Instructions on page 83

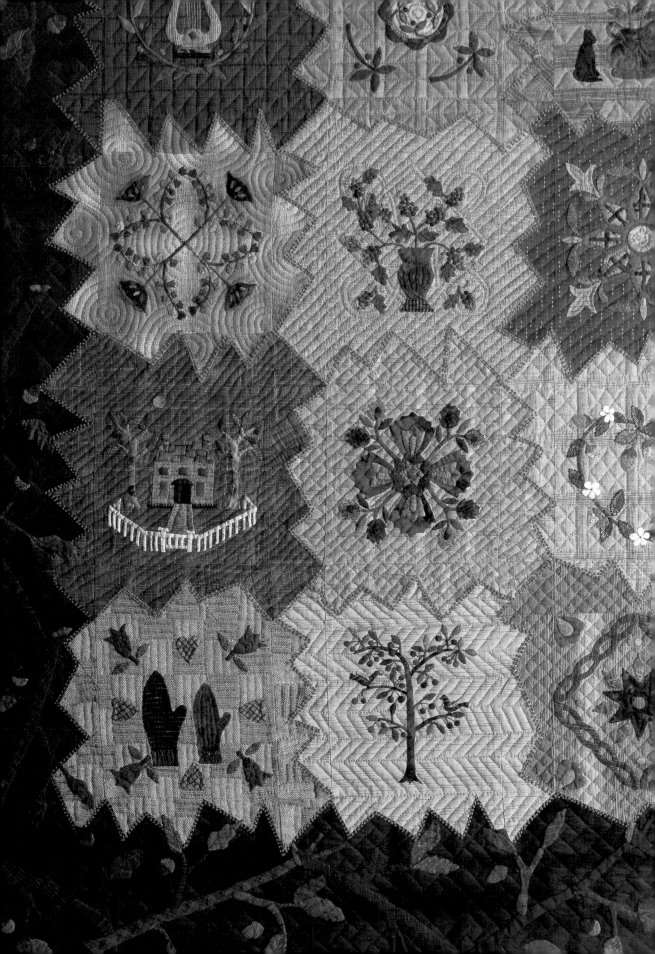

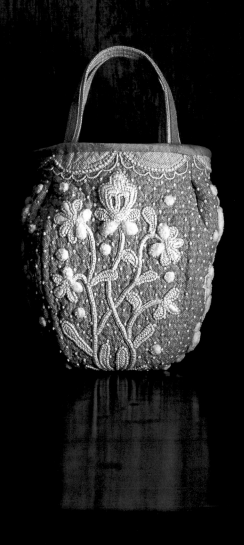

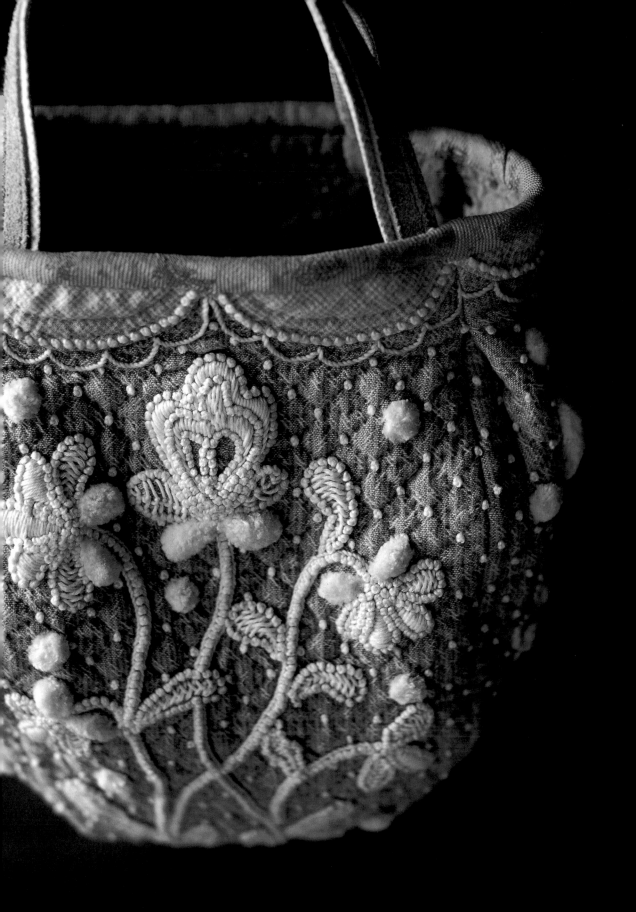

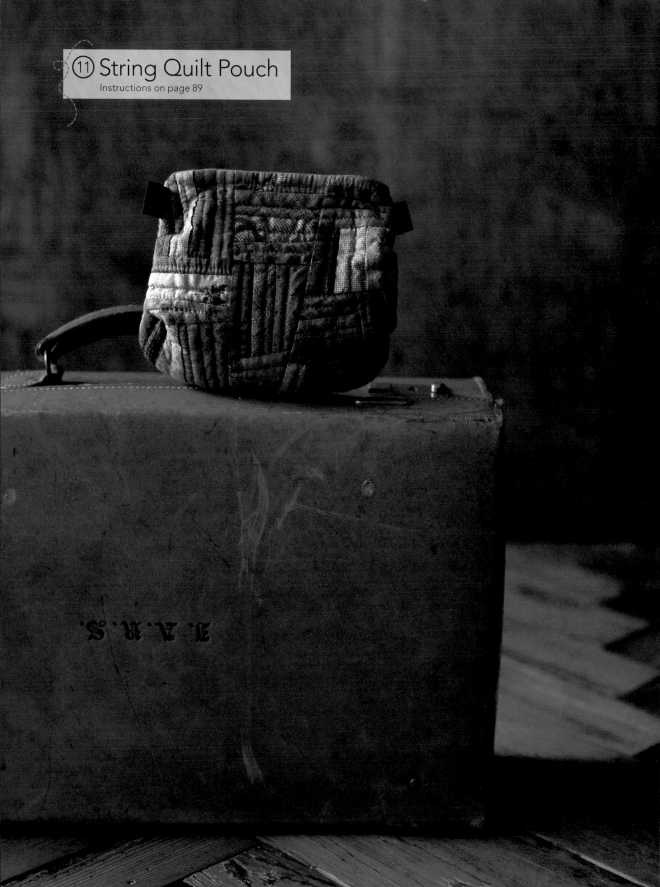

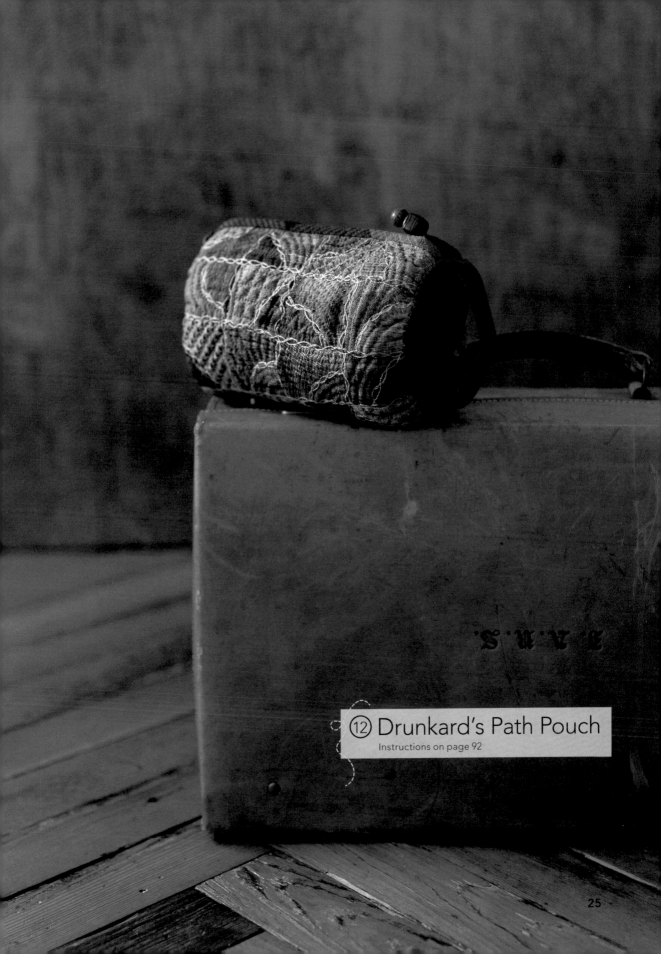

⑫ Drunkard's Path Pouch
Instructions on page 92

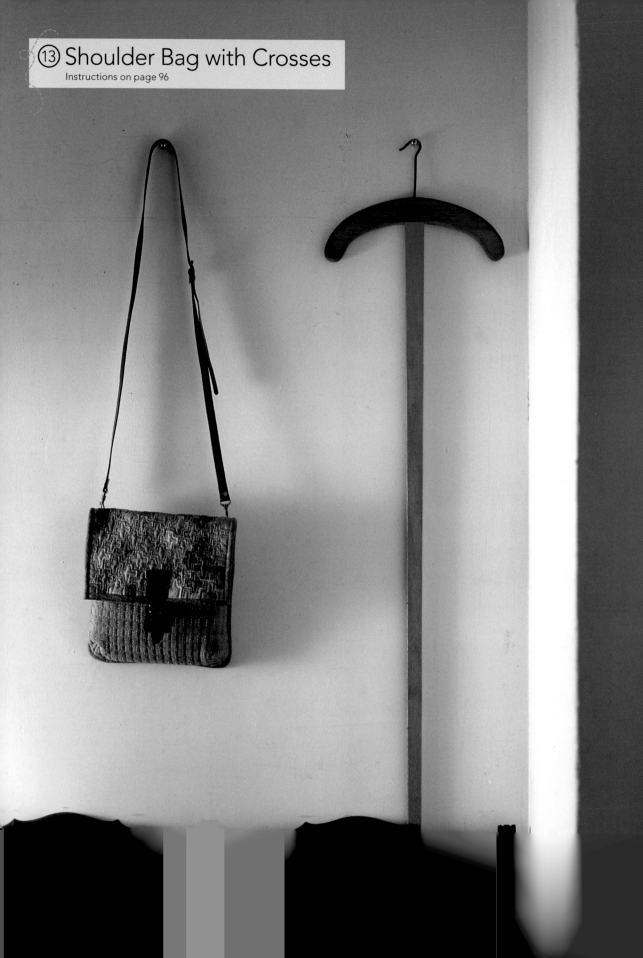

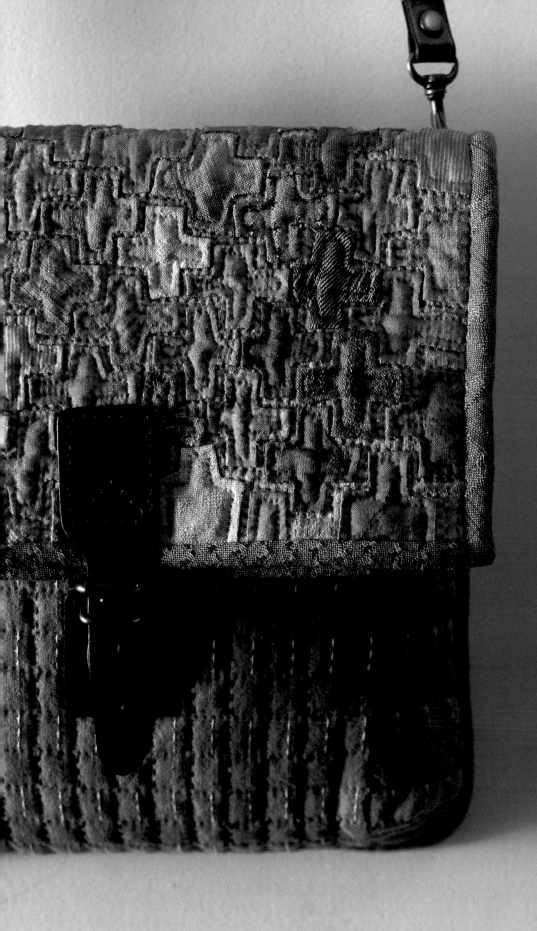

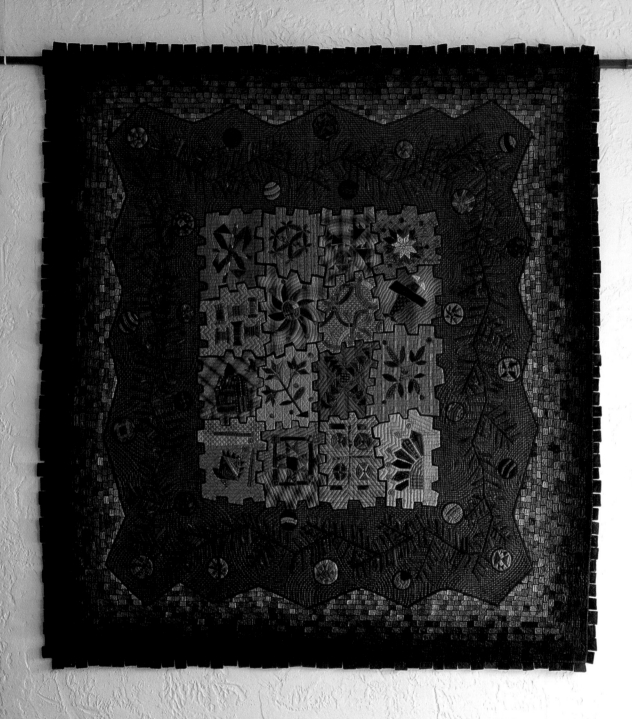

⑭ Appliqué Quilt Tapestry
Instructions on page 99

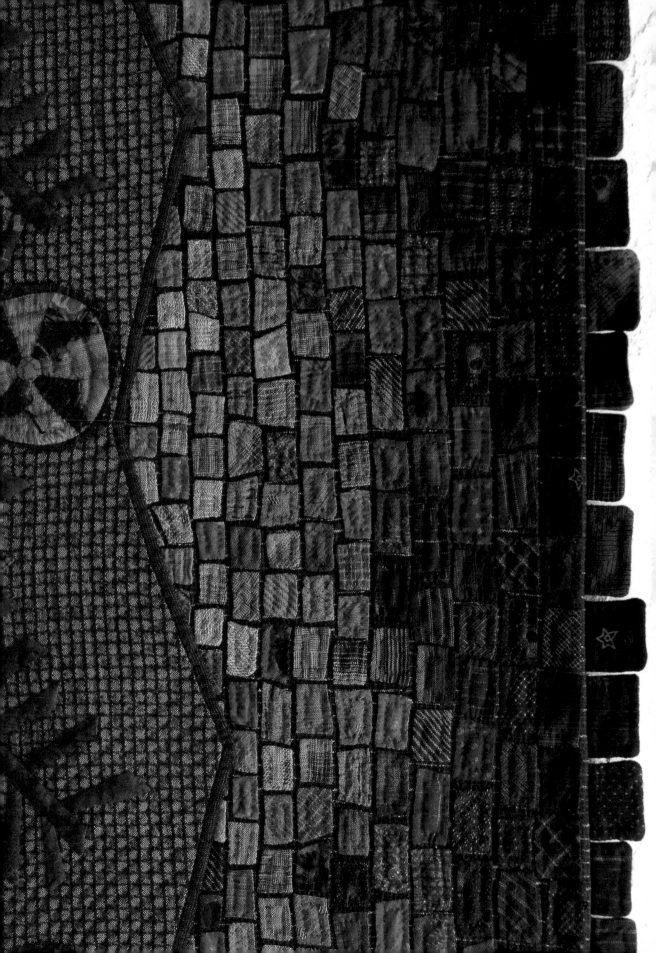

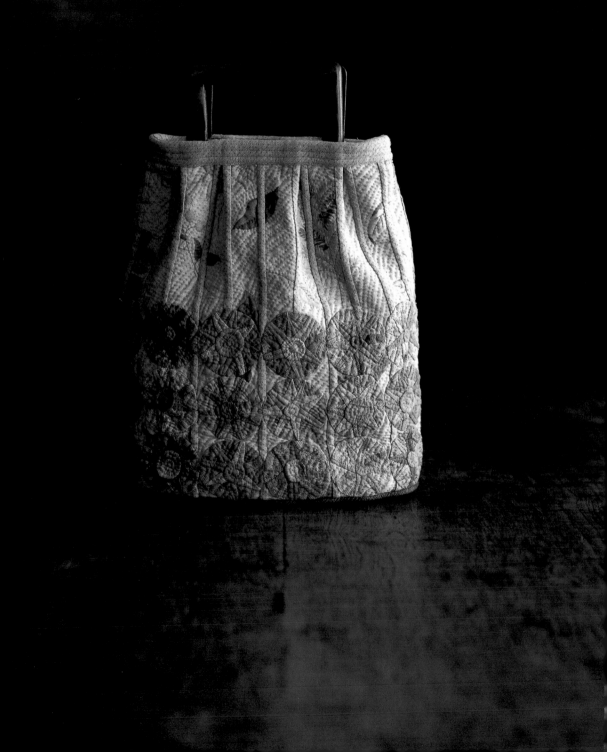

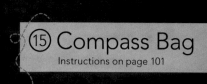

⑮ Compass Bag
Instructions on page 101

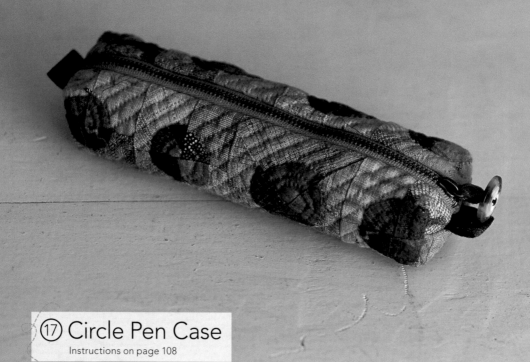

⑰ Circle Pen Case
Instructions on page 108

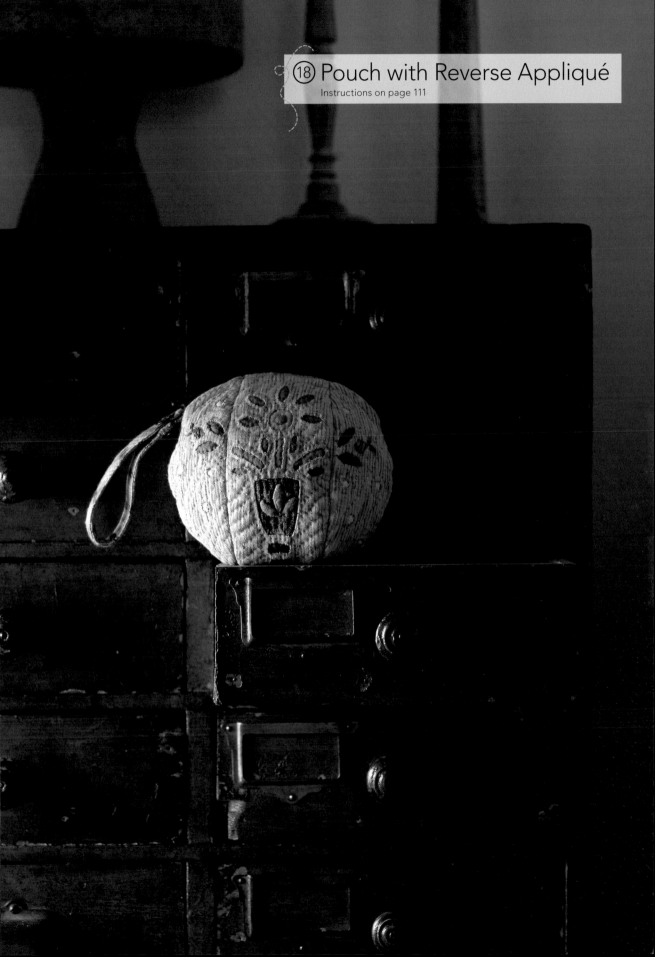

18 Pouch with Reverse Appliqué
Instructions on page 111

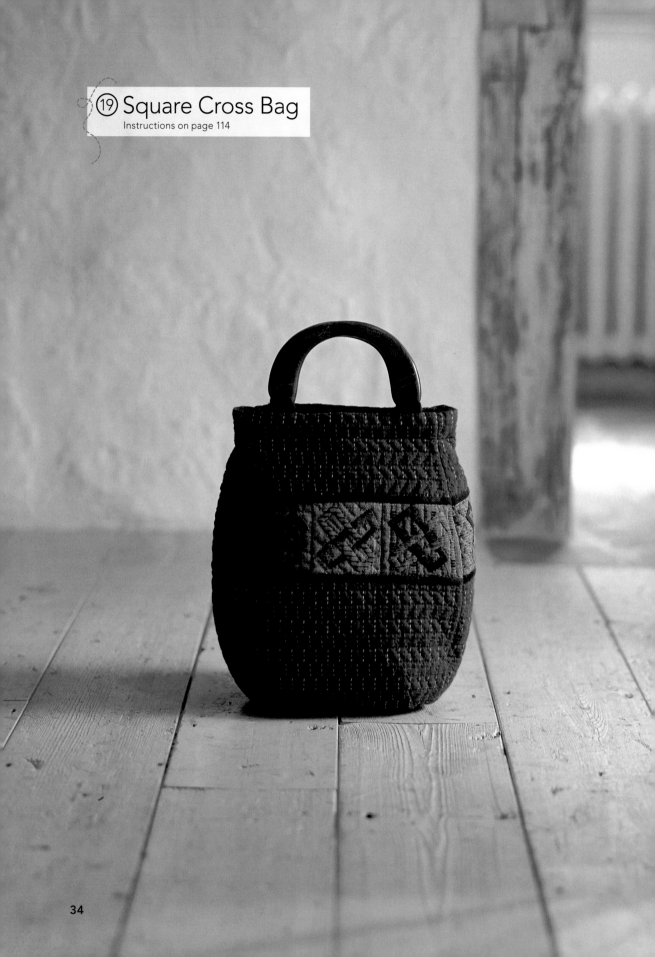

⑲ Square Cross Bag
Instructions on page 114

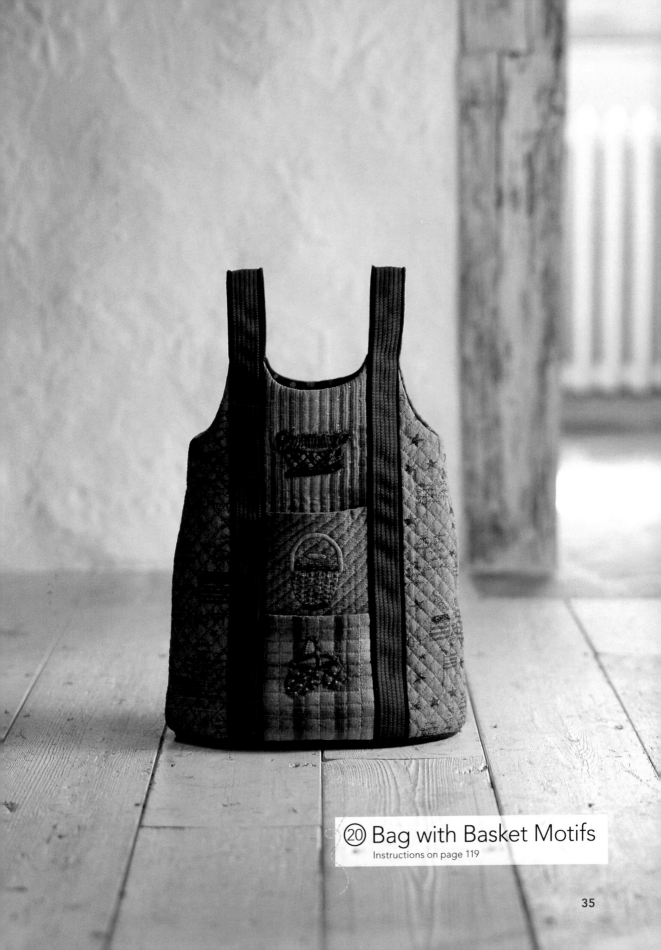

⑳ Bag with Basket Motifs
Instructions on page 119

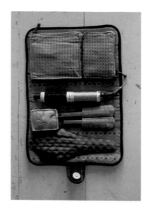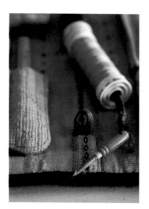

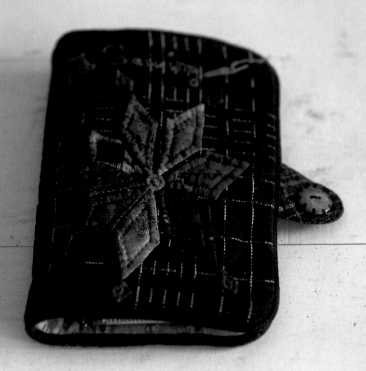

(21) Sewing Case with Lemon Star Appliqué

Instructions on page 123

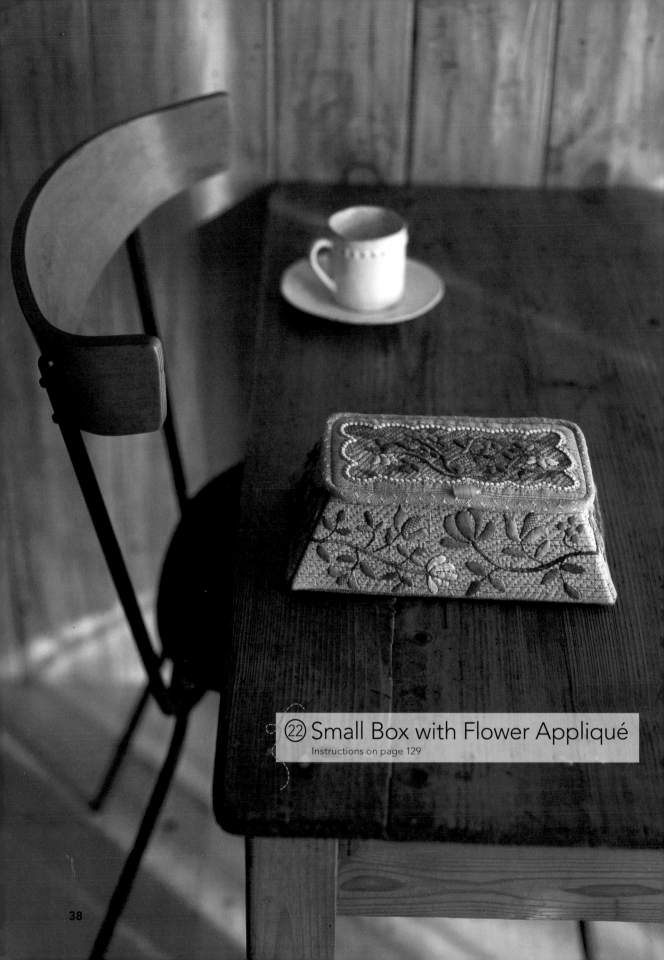

㉒ Small Box with Flower Appliqué
Instructions on page 129

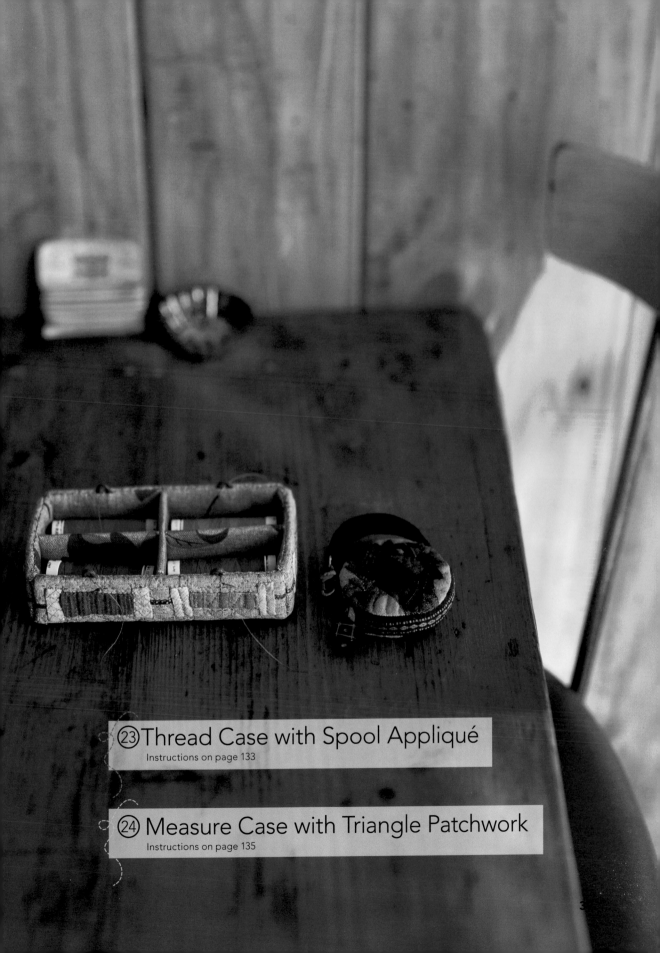

㉓ Thread Case with Spool Appliqué
Instructions on page 133

㉔ Measure Case with Triangle Patchwork
Instructions on page 135

㉕ Hawaiian Quilt Tapestry
Instructions on page 137

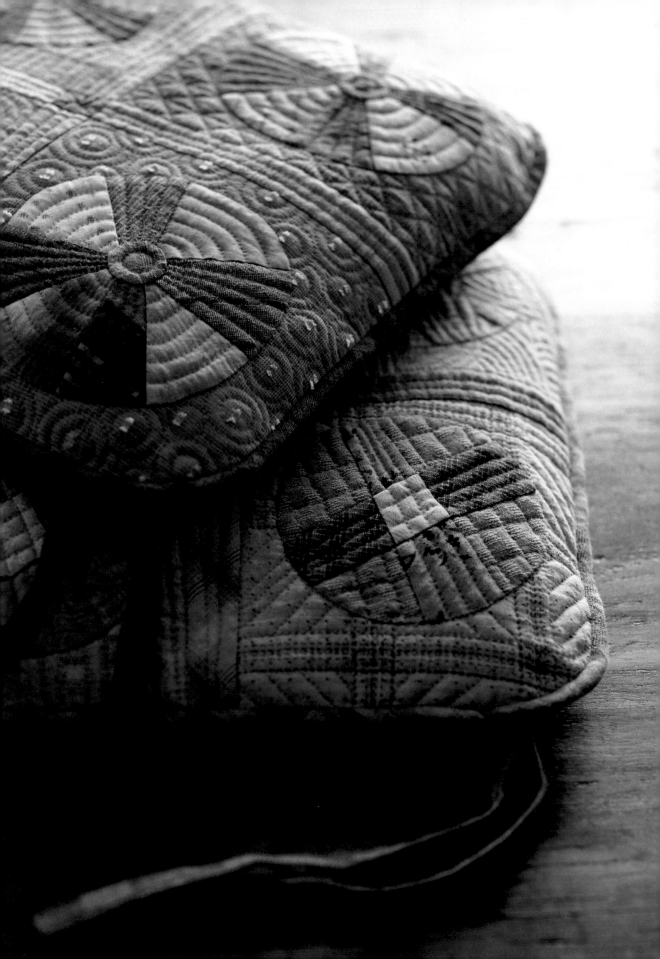

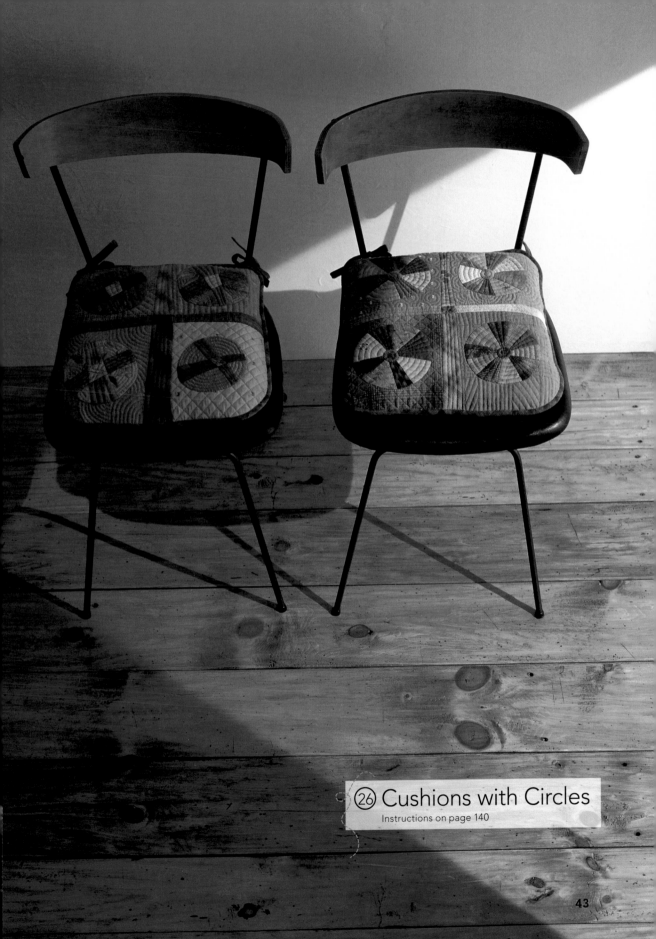

26 Cushions with Circles
Instructions on page 140

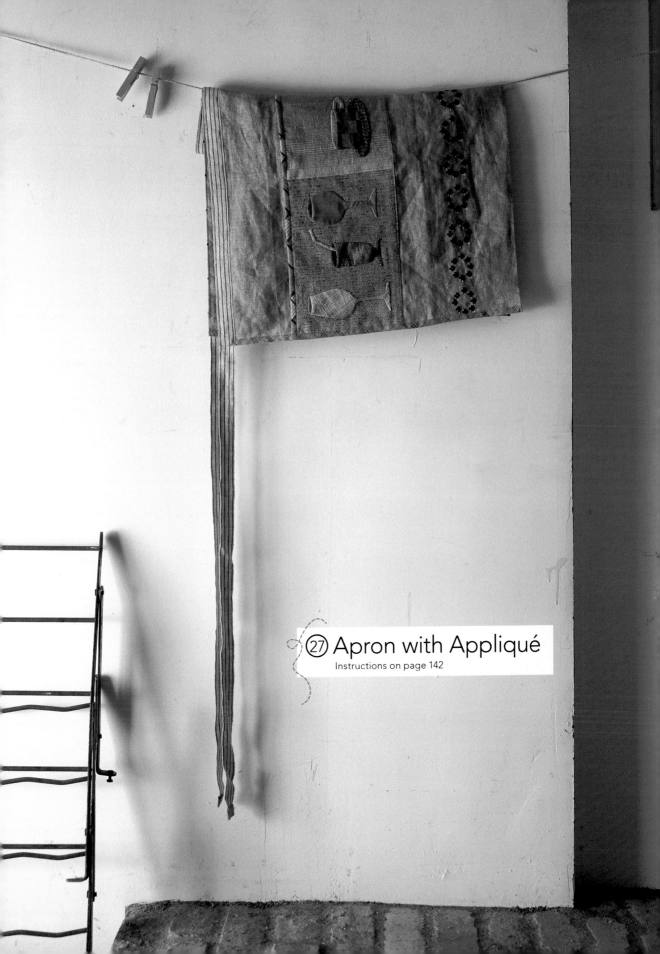

27 Apron with Appliqué

Instructions on page 142

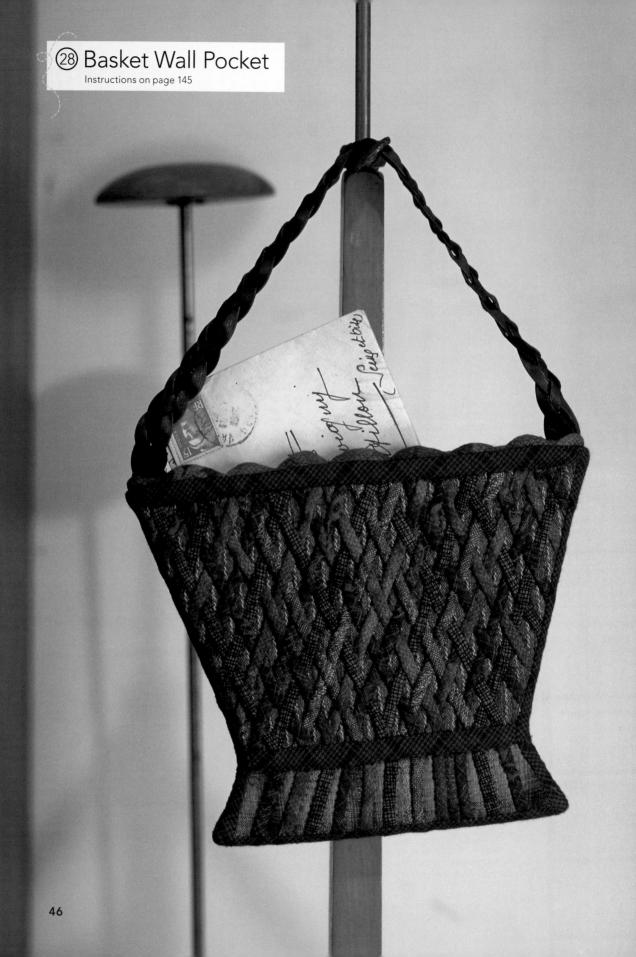

28 Basket Wall Pocket
Instructions on page 145

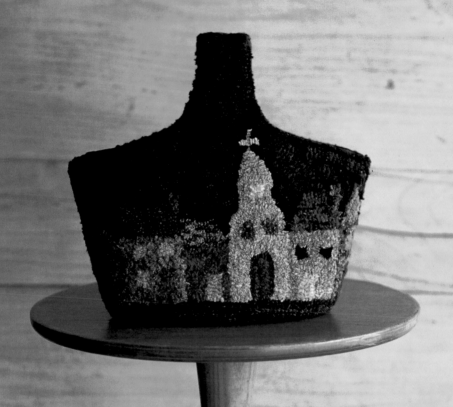

29 Hooked Rug Bag
Instructions on page 148

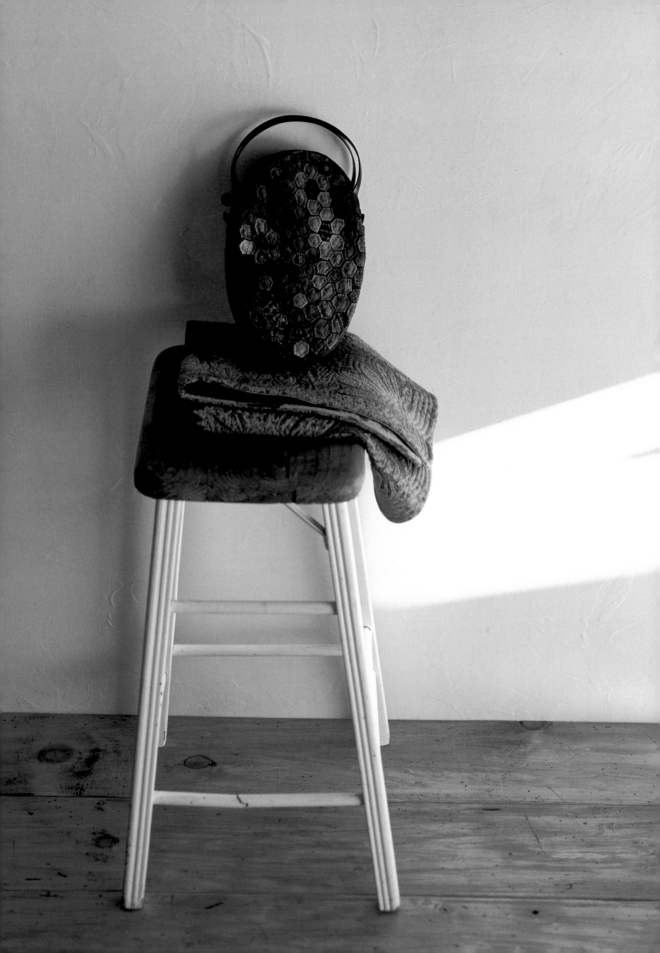

PART 2

Instructions

Before You Begin

Selecting Your Fabric

As one of the most popular color schemes in Japan, the use of neutrals can be traced back to the traditional textiles used for clothing and home furnishings by people living in the countryside during ancient times. As a result, the use of neutrals, specifically taupe, has become a signature characteristic of Japanese quilts. A neutral color scheme may sound boring, but don't be fooled: a quilt composed entirely of neutrals is often more fascinating than one with dozens of bright hues because it draws you in and invites you to examine the nuances of color.

Knowing the historical significance of neutrals, I was inspired to explore this color scheme, ultimately developing the signature style which is visible throughout the designs in the book. Using lots of taupe is not something I've done intentionally. In fact, I didn't realize how much I used it until people started talking about this color. To me, taupe is a subtle mixture of gray and brown with a touch of pink or blue. It is an extremely versatile color that blends perfectly with just about any color with which it is paired and can be used with cool colors, warm colors, and even prints to add a unique elegance.

Although neutrals are a key element in my designs, I greatly enjoy adding a dose of color to each project. When selecting fabrics, decide on a main color first, then select coordinating fabrics. I adamantly believe that balance among the entire quilt should take priority over using a favorite fabric. If a color is too bright or a print is too busy, I will often use the wrong side of the fabric to achieve a softer, more muted effect. Using an array of similar colors may be easy, but you won't learn anything from it. Play with your color schemes and try using many different shades. Not only will you add an unexpected depth to your quilt, you will gain experience and confidence.

For even more depth, I often choose to sew several small pieces of fabric together, even for large areas such as borders. As a result, the projects in this book often recommend using assorted scraps for the appliqué and patchwork pieces. Using scraps from your stash will contribute to the one-of-a-kind element of these designs.

Using the Templates

The pattern sheets include full-size templates for most of the projects in this book (the templates for two quilts are at half-scale). Trace the templates onto transparent paper—do not cut the pattern sheet. You'll need to create your own templates for some of the more simply shaped parts, such as handles and gussets. To create these templates, refer to the measurements listed in the cutting instructions for each project.

The templates for the patchwork and appliqué pieces are meant to serves as guides. You can use them as traditional templates by following them exactly, but we encourage you to experiment and create your own uniquely shaped pieces using the templates as inspiration.

In addition to serving as templates, the pattern sheets also include important information regarding appliqué placement, embroidery instructions, and construction order. It is a good idea to keep the pattern sheet nearby to use as a reference while you sew.

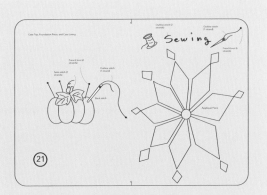

This example of a template for the Sewing Case with Lemon Star Appliqué shows the important information included on the pattern sheet.

When constructing these projects, always backstitch at the beginning and end of seams. This will add strength and durability to your bags, cases, and quilts so they will be able withstand the normal wear and tear of everyday use. Unless otherwise noted in the project instructions, use ¼"-⅜" (0.6-1 cm) seam allowance when sewing. For greatest accuracy, we recommend using the metric measurements, though conversion estimates are provided.

When quilting, always cut the batting and backing/lining larger than the top and baste the layers together from the center towards the outside. For each project, the instructions and diagrams provide quilting suggestions. Follow these recommendations, or quilt the pieces as you desire. Remember, this book is all about breaking free from convention!

Cutting

Note that the templates do not include seam allowance. Before cutting the fabric, add ¼" (0.6 cm) seam allowance for all pieces, except the appliqué pieces. For the appliqué pieces, add ⅛" (0.3 cm) seam allowance.

Some templates include marks noting important points, such as the center front or zipper placement. When cutting, make sure to transfer these marks to your fabric.

For more information on the fabrics used in this book, refer to page 152. For additional background on Yoko Saito's fabric selection process, check out *Quilter's Newsletter Magazine's* April 2004 interview with Yoko Saito.

Sewing

The projects in this book incorporate a combination of hand stitching and machine sewing techniques. Due to the small scale and detailed nature of these designs, the appliqué and embroidery is meant to be done by hand, while the sewing machine is great for creating sturdy seams and for quilting.

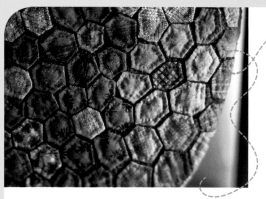

① Hexagon Bag

Photos on page 8-9

Materials

Appliqué fabric (for hexagon pieces):
 Assorted scraps

Main fabric (for bag front and back):
 8" x 12" (20 x 30 cm) each

Gusset fabric (for top and bottom
 gusset): 8" x 19¾" (20 x 50 cm)

Lining fabric (for bag and gusset
 linings, plus bias strips for lining):
 19¾" x 27½" (50 x 70 cm)

Bias fabric (for bag opening):
 Two 1½" x 12" (3.5 x 30 cm)
 bias strips

Tab fabric: 4¾" x 4¾" (12 x 12 cm)

Batting: 23½" x 27½" (60 x 70 cm)

Fusible interfacing (for top and
 bottom gusset): 6" x 19¾"
 (15 x 50 cm)

Woven interfacing (for the tab):
 2" x 4" (5 x 10 cm)

Zipper: One 9½" (24 cm) zipper

Handle: One set of ¼" x 26"
 (0.6 x 66 cm) leather handles

Bead: One ⅝" (1.5 cm)
 diameter wooden bead

Cording: Small amount of waxed
 cording

Cut the fabric.

Trace and cut out the templates on Pattern Sheet A. Using the templates, cut out the hexagons pieces*, front, back, front lining, and back lining. Cut out the following pieces, which do not have templates, according to the measurements below:

✂ Top gussets: Two 1¾" x 11" (4.3 x 28 cm) pieces

✂ Top gusset linings: cut two pieces slightly larger than top gussets

✂ Bottom gusset: One 3¼" x 17¼" (8 x 44 cm) piece

✂ Bottom gusset lining: cut one piece slightly larger than bottom gusset

✂ Tab pieces: Four 2" x 2" (5 x 5 cm) pieces

✂ Opening edge bias strips: Two 1½" x 12" (3.5 x 30 cm) bias strips

✂ Lining bias strips: 1½" (2.5 cm) wide bias strips

*The numbers on the hexagon templates represent fabrics. Use the same fabric for templates with the same number.

A. Appliqué the hexagon pieces to the bag front.

① Use the diagram below as a layout guide to appliqué the hexagon pieces to the bag front using a blind hemstitch.

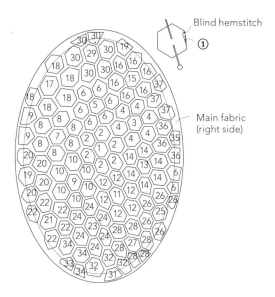

Blind hemstitch ①

Main fabric
(right side)

B. Make the bag front.

① Layer the front, batting, and lining. Baste.
② Quilt, as shown in the diagram.
③ Draw the finishing line ⅜" (1 cm) from the edge.
④ Trim the excess batting.

C. Make the bag back, following the same process as for the bag front in Step B.

① Layer the back, batting, and lining. Baste.
② Quilt, as shown in the diagram.
③ Draw the finishing line ⅜" (1 cm) from the edge.
④ Trim the excess batting.

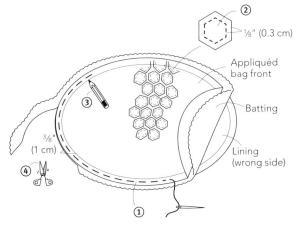

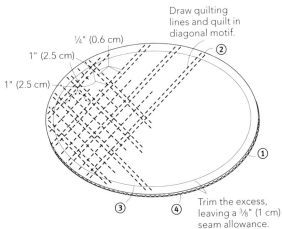

D. Make the top gussets and install the zipper.

① Press fusible interfacing to the wrong side of the top gusset lining.
② Layer the gusset, batting, and lining. Baste.
③ Draw quilting lines at 45-degree angles about ⅜" (1 cm) apart and quilt.
④ Draw the finishing line ⅜" (1 cm) from the edges.
⑤ With right sides together, sew an opening edge bias strip to the gusset, using a ¼" (0.6 cm) seam allowance.
⑥ Trim remaining seam allowances, including batting, to ⅜" (1 cm).
⑦ Fold bias strip to the wrong side of the top gusset. Backstitch the zipper to the binding, about ¼" (0.6 cm) from the zipper teeth.
⑧ Hemstitch the zipper edge to the top gusset.
⑨ Repeat Steps 1-8 for the other top gusset.

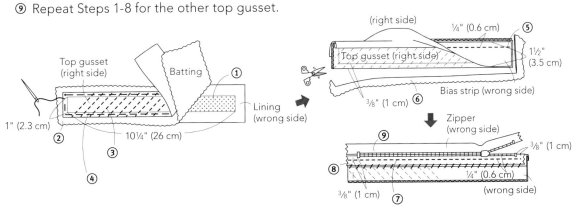

E. Make the bottom gusset.

① Press fusible interfacing to the wrong side of the bottom gusset lining.
② Layer gusset, batting, and lining. Baste.
③ Draw quilting lines at 45-degree angles about ⅜" (1 cm) apart and quilt.
④ Draw the finishing line ⅜" (1 cm) from the edges.
⑤ Trim the seam allowance to ⅜" (1 cm), except for the short edges of the lining. Leave these seam allowances at ¾" (2 cm).

F. Make the tabs.

① Layer woven interfacing with one tab piece on the wrong side.
② Align interfaced tab piece with an uninterfaced tab piece and sew with right sides together, using ⅜" (1 cm) seam allowances. Turn right side out.
③ Topstitch, as shown in the diagram. Fold in half.

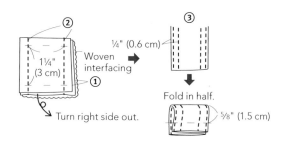

*Make two tabs.

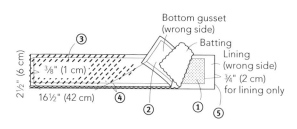

G. Attach tabs and sew the gussets together.

① Baste the tabs to the short edges of the top gusset on the right side.
② With right sides together, sew the bottom gusset to the top gusset along the short edges, using a ¾" (2 cm) seam allowance.
③ Trim only the top gusset seam allowances to ¼" (0.6 cm) along the short edges.
④ Wrap the bottom gusset seam allowance around the top gusset seam allowance and hemstitch.

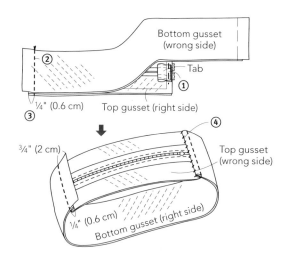

H. Sew the bag together.

① Baste the handles to the right side of both the bag front and back.
② Leave the zipper open and sew the gusset to both the bag front and back.

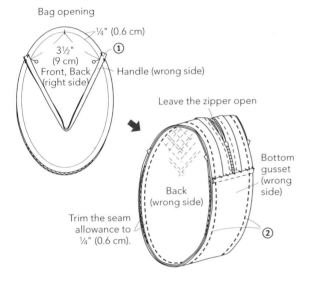

Bag opening

¼" (0.6 cm)

3½"
(9 cm)
Front, Back
(right side)

① Handle (wrong side)

Leave the zipper open

Bottom
gusset
(wrong
side)

Back
(wrong side)

Trim the seam
allowance to
¼" (0.6 cm).

②

I. Finish the seam allowances.

① With right sides together, sew a lining bias strip to bag front seam allowance. Wrap the bias strip around the bag front seam allowance and hemstitch.
② Repeat Step 1 for the bag back seam allowance.

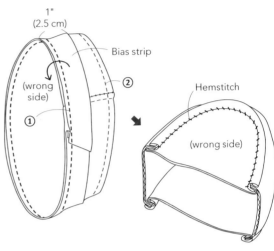

1"
(2.5 cm)

Bias strip

②

(wrong
side)

①

Hemstitch

(wrong side)

J. Make the zipper charm.

① Make a zipper charm by stringing the bead onto cording and tying onto the zipper pull.

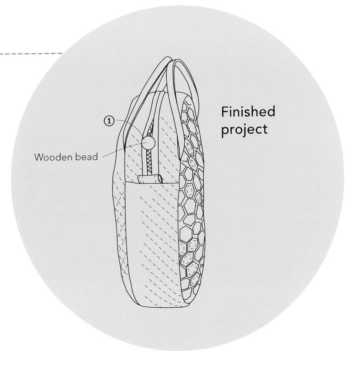

①

Wooden bead

Finished
project

② Orange Blossom Bag

Photos on pages 10-11

Materials

Appliqué fabric: Assorted scraps

Main fabric (for bag sides, top gusset, pocket facing, and pocket lining): 11¾" x 43¼" (30 x 110 cm)

Bottom gusset fabric: 6" x 23½" (15 x 60 cm)

Handle attachment fabric: 3" x 12" (7.5 x 30.5 cm)

Lining fabric (for bag and gusset linings, plus bias strips for lining): 19¾" x 43¼" (50 x 110 cm)

Fusible interfacing (for pocket facing, handle attachments, and top and bottom gussets): 11¾" x 19¾" (30 x 50 cm)

Batting: 19¾" x 31½" (50 x 80 cm)

Zippers:
One 4¾" (12 cm) zipper
One 10¼" (26 cm) zipper

Handles: One set of 2¼" x 5½" (6 x 14 cm) handles

Cording: Small amount of waxed cording

Beads:
One ¼" (0.6 cm) diameter round wooden bead
One 1¼" (3 cm) teardrop wooden bead

Buttons: Two ¾" (2 cm) diameter decorative buttons

Cut the fabric.

Trace and cut out the templates on Pattern Sheet A. Using the templates, cut out the petals, bag sides, bag linings, pocket facing, pocket lining, top gusset, top gusset lining, bottom gusset, and bottom gusset lining. Cut out the following pieces, which do not have templates, according to the measurements below:

✂ Handle attachment pieces: Eight 1½" x 3" (3.2 x 7.2 cm) pieces

✂ Lining bias strips: 1" (2.5 cm) wide bias strips

A. Appliqué the petals to the bag sides and quilt.

① Use the diagram below as a layout guide to appliqué the petals to the bag sides. To appliqué, fold the seam allowance along the finishing lines using the needle tip and blind hemstitch.

② Layer the side, batting, and lining. Quilt, as shown in the diagram.

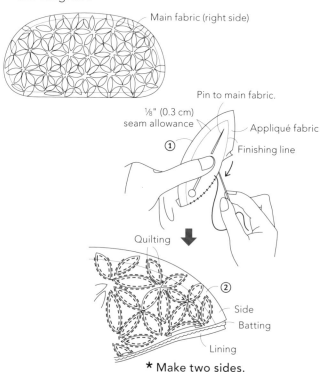

Main fabric (right side)

Pin to main fabric.

⅛" (0.3 cm) seam allowance

Appliqué fabric

① Finishing line

Quilting

② Side

Batting

Lining

* Make two sides.

B. Make the pocket opening.

① Press fusible interfacing to the wrong side of the pocket facing. With right sides together, sew facing to one bag side along the mark, using a short stitch length.
② Cut through all layers, as shown in the diagram. Make sure not to cut through stitching. Pull the facing to the wrong side through the opening.
③ On the wrong side, fold the facing seam allowance under and hemstitch to the lining.
④ Baste the zipper in place.
⑤ Hemstitch the zipper edge to the lining.
⑥ Topstitch, as shown in the diagram, to secure the zipper in place.

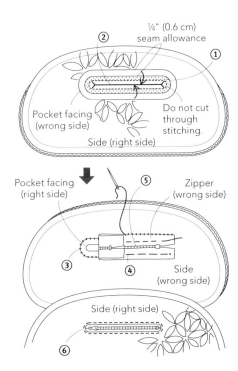

C. Attach the pocket lining.

① Baste pocket lining to bag side lining along three edges.
② Hemstitch pocket lining to bag side lining along fold.

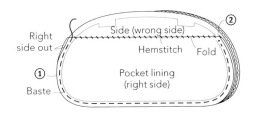

D. Make the top gusset.

① Press fusible interfacing to the wrong side of the top gusset lining.
② With right sides together, sew the top gusset lining, top gusset, and batting along the mark, using a short stitch length.
③ Cut through all layers, as shown in the diagram. Make sure not to cut through stitching. Pull the top gusset lining to the batting side through the opening.
④ Install the zipper, following Steps 4-6B above.
⑤ Quilt, as shown in the diagram.
⑥ With right sides together, sew a bias strip to each short edge of the top gusset. Trim the seam allowances to ¼" (0.6 cm).
⑦ Wrap the binding around the seam allowance and hemstitch to the lining.

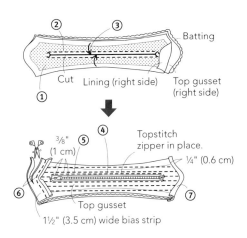

E. Make the bottom gusset.

① Press fusible interfacing to the wrong side of the bottom gusset lining.
② With right sides together, layer bottom gusset lining, bottom gusset, and batting. Sew along the short edges.
③ Trim the batting along the short edge seam allowances.
④ Turn right side out. Draw quilting lines and machine quilt 45 degree angle rows, about ⅜" (1 cm) apart, in both directions.

F. Attach the top and bottom gusset.

① With right sides together, hemstitch the top and bottom gusset together along the mark.

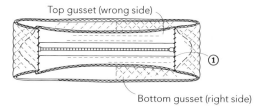

Top gusset (wrong side)

① Bottom gusset (right side)

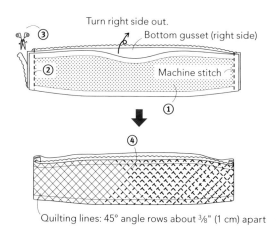

Turn right side out.
③
② Bottom gusset (right side)
Machine stitch
①
④
Quilting lines: 45° angle rows about ⅜" (1 cm) apart

G. Make the handle attachments.

① Press fusible interfacing to the wrong side of one handle attachment piece.
② With right sides together, sew one interfaced handle attachment piece to one uninterfaced handle attachment piece, using a ¼" (0.6 cm) seam allowance.
③ Turn right side out.
④ Quilt, as shown in the diagram.
⑤ Thread the handle attachments through the holes in the handles.
⑥ Baste the short edges of the handle attachments together, about ½" (1.3 cm) from the handle opening.

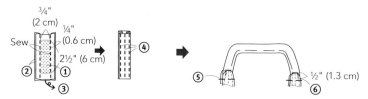

¾" (2 cm)
¼" (0.6 cm)
Sew
2½" (6 cm)
② ①
③
④
⑤
½" (1.3 cm)
⑥

★ Make four handle attachments.

H. Sew the bag together.

① Press tucks on both bag sides, as shown in the diagram.
② Baste handles onto both bag sides along existing basting.
③ Leave the zipper halfway open and baste gusset to both sides of bag.
④ Sew gusset to both sides of bag.
⑤ With right sides together, sew a lining bias strip to one bag side seam allowance.
 Wrap the bias strip around the bag side seam allowance and hemstitch.
 Repeat for the other bag side seam allowance.

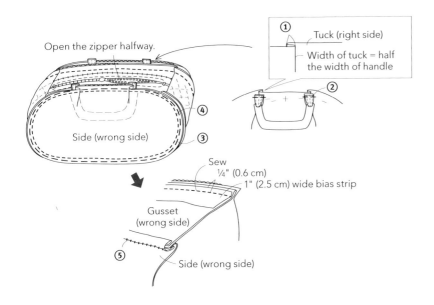

Open the zipper halfway.

① Tuck (right side)

Width of tuck = half the width of handle

②

Side (wrong side)

④

③

Sew ¼" (0.6 cm)

1" (2.5 cm) wide bias strip

Gusset (wrong side)

⑤

Side (wrong side)

I. Make the zipper charm.

① Make the zipper charm, as shown in the diagram. Attach the zipper charm and decorative buttons to the bag.

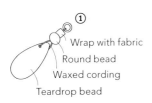

①

Wrap with fabric

Round bead

Waxed cording

Teardrop bead

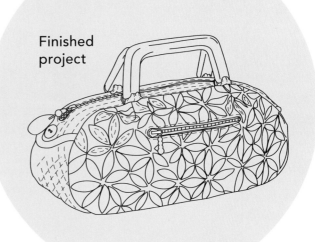

Finished project

③ Bag with Variant Squares

Photos on pages 12-13

Materials

Patchwork fabric (for the rectangles for pockets): Assorted scraps

Main fabric (for the bag foundation, pocket lining, and flap): 11¾" x 43¼" (30 x 110 cm)

Handle attachment fabric: 2¾" x 6¼" (7 x 16 cm)

Lining fabric: 9¾" x 19¾" (25 x 50 cm)

Tab fabric: Small scrap

Bias strip fabric (for bag opening and edges):
One 1" x 19¾" (2.5 x 50 cm) bias strip and one 1½" x 47¼" (3.5 x 120 cm) bias strip

Batting: 11¾" x 43¼" (30 x 110 cm)

Fusible interfacing (for handle attachments and tab): 2¼" x 2¾" (6 x 7 cm)

Hook and loop tape: ¾" x 1" (2 x 2.5 cm)

Magnetic button: One ⅞" (2.2 cm) diameter magnetic button set

Decorative button: One 1" (2.5 cm) diameter decorative button

Handle: One set of handles with an inner width of 3½" (9 cm)

Embroidery floss: 6-strand embroidery floss

Cut the fabric.

Trace and cut out the templates on Pattern Sheet A. Using the templates, cut out the rectangle pieces, bag foundations, bag linings, flap, and tab. Cut out the following pieces, which do not have templates, according to the measurements below:

✂ Handle attachment pieces: Four 1½" x 2½" (3.5 x 6 cm) pieces

✂ Bag opening bias strip: One 1" x 19¾" (2.5 x 50 cm) bias strip

✂ Bag edges bias strip: One 1½" x 47¼" (3.5 x 120 cm) bias strip

A. Make the bag foundations.

① Layer the bag foundation, batting, and lining.

② Quilt, following the design of the bag foundation fabric.

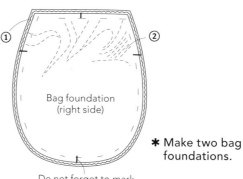

Bag foundation (right side)

✱ Make two bag foundations.

Do not forget to mark.

B. Make the handles.

① Press fusible interfacing to the wrong side of one handle attachment piece.
② With right sides together, sew one interfaced handle attachment piece to one uninterfaced handle attachment piece.
③ Turn right side out and topstitch, as shown in the diagram.
④ Repeat Steps 1-4 for the other handle attachment.
⑤ Thread the handle attachments through the holes in the handle. Baste the short edges of the handles attachments together.

Handle attachments

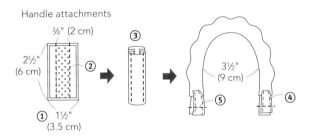

C. Sew the bag together.

① With right sides together, sew the bag foundations together along the top edge with the handles sandwiched in between.

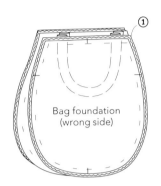

Bag foundation (wrong side)

D. Make the pockets.

① Sew the rectangles of assorted scraps together to create a piece large enough for two pockets. Using the pocket template on Pattern Sheet A, cut out two pockets.
② Layer each pocket, batting, and pocket lining. Quilt, as shown in the diagram.
③ Cut the bag opening bias strip in half. With right sides together, sew half of the bag opening bias strip to the top edge of one pocket using a ¼" (0.6 cm) seam allowance.
④ Wrap the bias strip around the seam allowance and hemstitch.
⑤ Sew darts on both pockets.
⑥ Press fusible interfacing to the wrong side of one tab piece. With right sides together, sew the interfaced tab piece to the uninterfaced tab piece.
⑦ Turn right side out. Topstitch, as shown in the diagram.
⑧ With right sides together, sew the other half of the bag opening bias strip to the top edge of second pocket, with the tab sandwiched in between.
⑨ Wrap the bias strip around the seam allowance and hemstitch.

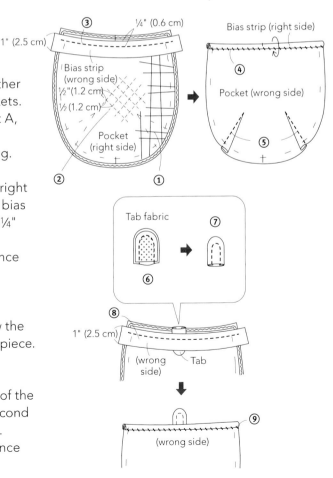

E. Attach the pockets.

① Baste a pocket to each bag foundation.
② With right sides together, sew the bag edges bias strip around the bag using a ¼" (0.6 cm) seam allowance. Make a ¼" (0.6 cm) fold on the short edge of the first bias strip, then start sewing. Use this fold as the seam allowance to attach the other end of the bias strip.
③ Wrap the bias strip around the seam allowance and hemstitch.

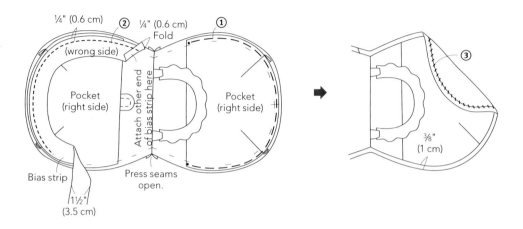

F. Topstitch.

① Topstitch the top edge of the bag using a ½" (1.2 cm) seam allowance.

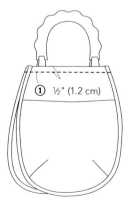

G. Make the flap.

① Layer two flap pieces with right sides together on top of batting.
 Sew around the flap outline, leaving an opening to turn right side out.
② Trim excess batting.
③ Turn flap right side out and hemstitch the opening closed.
④ Quilt, following the design of the flap fabric.
⑤ Embroider the flap with the colonial knot stitch using three strands of embroidery floss
 (refer to page 95).
⑥ Attach the flap to the right side of the bag using a narrow ladder stitch.
⑦ Attach a magnetic button on the inside (refer to page 128) and a decorative button on the outside.

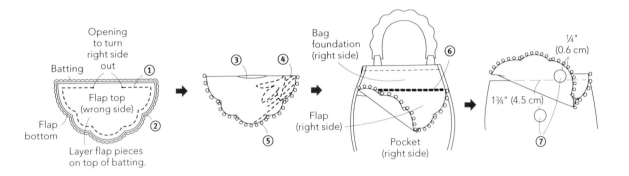

H. Attach the hook and loop tape.

① Attach a piece of hook and loop tape to the
 wrong side of the pocket and to the right side
 of the bag underneath the tab.

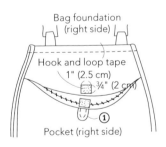

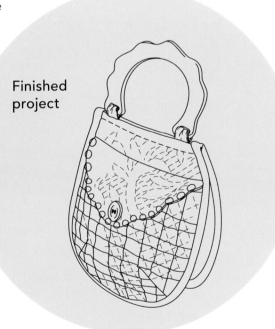

Finished
project

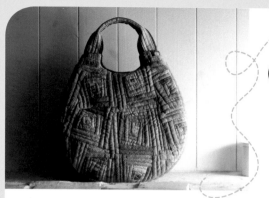

④ Log Cabin Bag

Photo on page 14

Materials

Patchwork fabric: Assorted scraps

Gusset fabric: 19¾" x 23½"
(50 x 60 cm)

Handle fabric: 4¾" x 9¾"
(12 x 25 cm)

Lining fabric (for bag side linings,
gusset lining, facing, handles,
and bias strips): 23½" x 43¼"
(60 x 110 cm)

Fusible interfacing:
11¾" x 27½" (30 x 70 cm)

Batting : 23½" x 31½" (60 x 80 cm)

Twill tape: 19¾" (50 cm) of
1" (2.5 cm) wide twill tape

Cut the fabric.

Trace and cut out the templates on Pattern Sheet A.
Using the templates, cut out the log cabin block pieces, bag
sides, bag side linings, gusset, gusset lining, facings, and
handles. Cut out the following pieces, which do not have
templates, according to the measurements below:

✂ Lining bias strips: Two 1" (2.5 cm) wide bias strips

A. Make the bag sides.

① Make the log cabin
blocks, as shown on
page 67.
② Appliqué the log cabin
blocks together into the
shape of the bag sides.

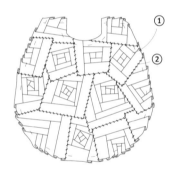

B. Quilt the bag sides.

① Layer the bag side, batting, and lining.
② Baste around the outline of the bag. Baste horizontal,
vertical, and diagonal seams. Always baste from the center
towards the outside, rotating the fabric as you work.
③ Quilt the log cabin blocks, as shown in the diagram.

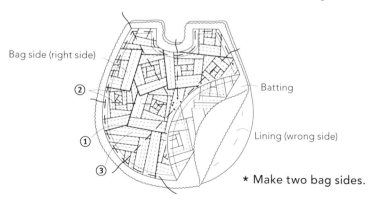

Bag side (right side)

Batting

Lining (wrong side)

★ Make two bag sides.

C. Make the gusset.

① Press fusible interfacing to the wrong side of the gusset lining.
② With right sides together, layer the gusset, gusset lining, and batting. Sew along the short edges.
③ Trim the batting along the short edge seam allowances.
④ Turn right side out.
⑤ Draw quilting lines and machine quilt to make ½" x ½" (1.2 x 1.2 cm) squares.

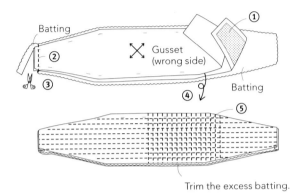

Batting

② ③ Gusset (wrong side) ① Batting ④ ⑤

Trim the excess batting.

D. Make the handles.

① Press fusible interfacing to the wrong side of one handle piece.
② With right sides together, sew one interfaced handle piece to one uninterfaced handle piece using a ¼" (0.6 cm) seam allowance.
③ Trim the batting along the seam allowances.
④ Turn right side out.
⑤ Layer a piece of twill tape on top of the handle and machine quilt six vertical lines through all layers.
⑥ Fold the handle in half widthwise and machine stitch together along center 4" (10 cm) of the handle.

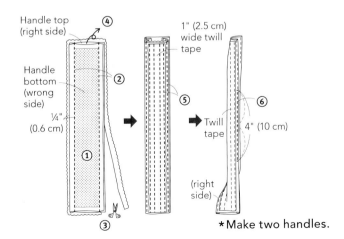

Handle top (right side) ④
Handle bottom (wrong side) ②
¼" (0.6 cm)
①
③
1" (2.5 cm) wide twill tape
⑤
Twill tape
(right side)
⑥
4" (10 cm)

*Make two handles.

E. Make the facings.

① Press fusible interfacing to the wrong side of each facing.
② Fold the bottom seam allowance and press.

F. Sew the bag together.

① With right sides together, baste one handle to one bag side. Repeat for second handle and bag side.
② Sew gusset to both sides of the bag.
③ Working with one bag side at a time, sew a facing to each bag side. Turn the facing to the inside of the bag.

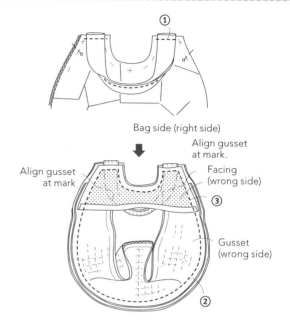

Bag side (right side)

Align gusset at mark

Align gusset at mark.

Facing (wrong side)

③

Gusset (wrong side)

②

G. Finish the seam allowances.

① With right sides together, sew a lining bias strip to the gusset, using a ¼" (0.6 cm) seam allowance.
② Wrap the bias strip around the seam allowance and hemstitch.
③ Hemstitch the facing to the lining.
④ Repeat Steps 1-3 for the other side of the bag.

Finished project

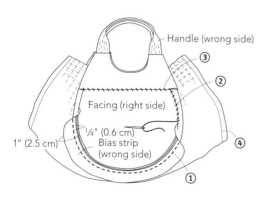

Handle (wrong side)

③

②

Facing (right side)

¼" (0.6 cm)

1" (2.5 cm) Bias strip (wrong side)

④

①

How to make a free-form log cabin block

① Sew pieces of varying widths together one by one, starting at the center and working in a counterclockwise direction. Continue until the block is complete.
② Press the seam allowances outward.
③ Fold the seam allowance and blind hemstitch to finish the raw edges of the log cabin block.

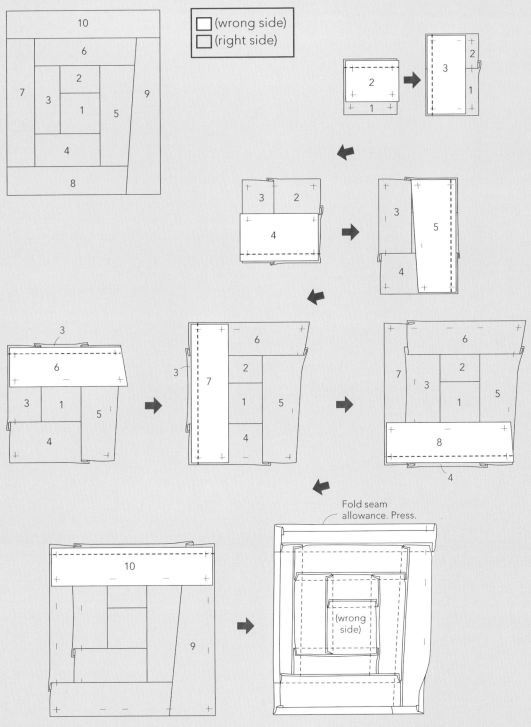

Fold seam allowance. Press.

(wrong side)

⑤ Rugby-Ball-Shaped Bag with Spools

Photo on page 15

Materials

Patchwork bag and appliqué fabric: Assorted scraps

Tab fabric: 1½" x 1½" (4 x 4 cm)

Cap fabric: 2" x 4" (5 x 10 cm)

Facing fabric: 4" x 9¾" (10 x 25 cm)

Handle fabric (cut on the bias): 2" x 9¾" (5 x 25 cm)

Lining fabric (for bag section linings and handle lining): 13¾" x 31½" (35 x 80 cm)

Batting: 13¾" x 31½" (35 x 80 cm)

Fusible interfacing (for facing and handle): 8" x 8" (20 x 20 cm)

Zipper: One 6¼" (16 cm) zipper

Cording: Small amount of waxed cording

Decorative button: Two ¾" (2 cm) diameter decorative buttons

Beads (for zipper charm):
One ½" (1.2 cm) diameter round wooden bead
One ¾" (2 cm) tube bead

Cut the fabric.

Trace and cut out the templates on Pattern Sheet A. Using the templates, cut out bag sections A-F (top, middle, and bottom pieces), bag section linings, spools pieces, handle, handle lining, and caps.

A. Make the bag top.

① Make bag sections A-F by sewing top, middle, and bottom pieces together for each section.
② Appliqué spools to each section according to locations noted on the templates.
③ For each section, layer top, batting, and lining. Baste around the section outline. Baste horizontal, vertical, and diagonal seams.
④ Quilt as desired.

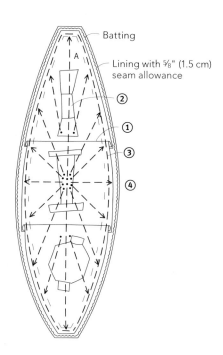

Batting

A

Lining with ⅝" (1.5 cm) seam allowance

②

①

③

④

B. Sew the six sections of the bag together.

① With right sides together, sew the six sections (A-F) together. When attaching A to F, only sew the bottom third together, leaving the remainder open for the zipper.

② Refer to the diagram below to finish seam allowances.

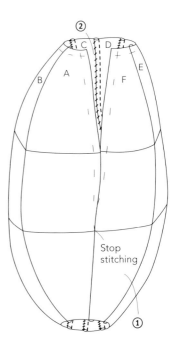

How to finish the seam allowances

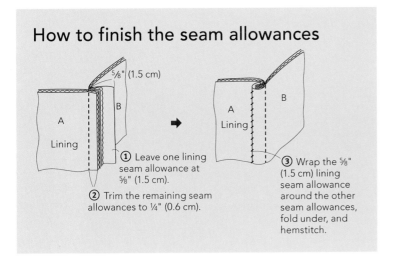

① Leave one lining seam allowance at ⅝" (1.5 cm).

② Trim the remaining seam allowances to ¼" (0.6 cm).

③ Wrap the ⅝" (1.5 cm) lining seam allowance around the other seam allowances, fold under, and hemstitch.

C. Install the zipper.

① Press fusible interfacing to the wrong side of each facing.

② With right sides together, sew one facing to raw edge of section A, stopping stitching ⅜" (1 cm) from the end of the interfacing. Repeat for other facing and section F.

③ Turn the facings to the inside of the bag and hand sew together at the bottom.

④ Hemstitch the facing to the bag lining.

⑤ On the right side, baste, then machine stitch the zipper to the bag, using a ¼" (0.6 cm) seam allowance.

⑥ Hemstitch the zipper to the bag lining.

* Make two facings.

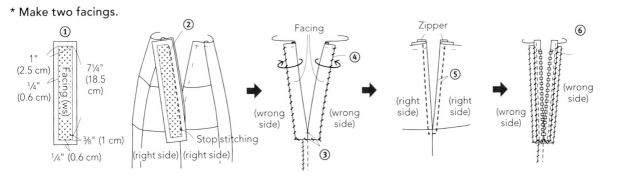

D. Make a tab and attach it to the bag.

① With right sides together, fold tab piece in half and sew, using a ¼" (0.6 cm) seam allowance. Press seam allowance open, as shown in the diagram.

② Sew one short edge together using a ¼" (0.6 cm) seam allowance.

③ Turn right side out.

④ Fold in half and topstitch to bag with finished edge facing up.

⑤ Make a zipper charm by stringing beads onto cording and tying onto the zipper pull.

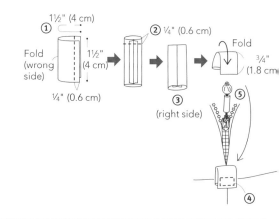

E. Attach the caps to the bag.

① With right sides together, sew two cap pieces and batting together, leaving an opening to turn right side out.

② Turn right side out and hemstitch opening closed.

③ On the inside of the bag, hemstitch the cap to the lining at the bottom of the bag.

④ Hemstitch the cap to the outside of the bag.

⑤ Quilt, using a ¼" (0.6 cm) seam allowance, as shown in the diagram. Repeat Steps 1-5 for other cap at the top of the bag.

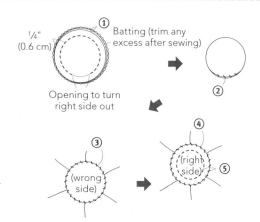

F. Make and attach the handle.

① Press fusible interfacing to the wrong side of the handle.

② With right sides together, sew handle, handle lining, and batting together, leaving an opening to turn right side out.

③ Turn right side out and topstitch, as shown in the diagram.

④ Hemstitch the opening closed.

⑤ Hemstitch the handle to the bag along short ends.

⑥ Attach decorative buttons.

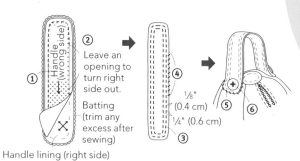

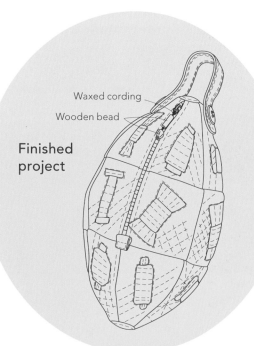

Waxed cording

Wooden bead

Finished project

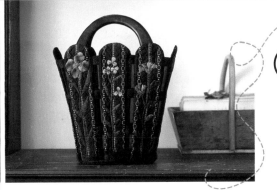

⑥ Basket with Flower Appliqué

Photos on pages 16-17

Materials

Appliqué fabric: Assorted scraps

Panel fabric (for panel tops and panel linings): 11¾" x 31½" (30 x 80 cm) each

Tulle (for bag side): 13¾" x 35½" (35 x 90 cm)

Accent fabric (for bottom lining and handle attachments): 23¾" x 25½" (60 x 65 cm)

Bottom fabric: 6" x 9¾" (15 x 25 cm)

Foundation fabric (for bottom): 6" x 9¾" (15 x 25 cm)

Bias strip fabric (for bag side): One 3¼" x 27½" (8 x 70 cm) bias strip and two 2" x 27½" (5 x 60 cm) bias strips

Batting: 13¾" x 35½" (35 x 90 cm)

Fusible interfacing (for bottom and handle attachments): 8" x 15¾" (20 x 40 cm)

Handle: One set of handles with inner width of 5" (12.5 cm)

Embroidery floss: 6-strand embroidery floss

Cut the fabric.

Trace and cut out the templates on Pattern Sheet A. Using the templates, cut out the panel tops, panel linings, bag side, bottom, and bottom lining. Cut out the following pieces, which do not have templates, according to the measurements below:

✂ Top bias strip: One 3¼" x 27½" (8 x 70 cm) bias strip

✂ Bias strips: Two 2" x 27½" (5 x 70 cm) bias strips

✂ Handle attachment pieces: Eight 1¾" x 3¼" (4.2 x 8.2 cm) pieces

A. Make the panels.

① Appliqué and embroider each panel top (refer to page 95 for embroidery instructions).
② With right sides together, sew the batting, panel top, and panel lining, using a ¼" (0.6 cm) seam allowance.
③ Trim excess batting and turn right side out.
④ Quilt, as shown in the diagram.

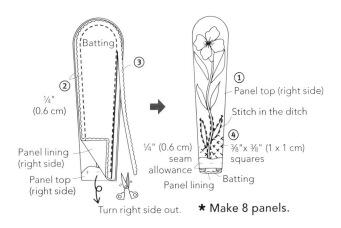

② ¼" (0.6 cm)

③ Batting

Panel lining (right side)

Panel top (right side)

Turn right side out.

① Panel top (right side)

Stitch in the ditch

④ ⅜" x ⅜" (1 x 1 cm) squares

¼" (0.6 cm) seam allowance

Panel lining

Batting

★ Make 8 panels.

⑤ BASKET WITH FLOWER APPLIQUÉ | 71

B. Make the facings.

① Press fusible interfacing to the wrong side of each facing.

Facing (wrong side)

¼" (0.6 cm)

①

C. Make the handles.

① Cut the nylon webbing and suede ribbon in half to make two 7½" (19 cm) long pieces of each. For each handle, layer a piece of suede ribbon on top of a piece of nylon webbing. Topstitch around the edges of the suede ribbon.

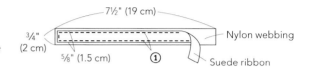

7½" (19 cm)

¾" (2 cm)

⅝" (1.5 cm)

①

Nylon webbing

Suede ribbon

D. Attach the handles and facings to the bag.

① With right sides together, sew the facings to the bag along the curve. Start and stop sewing 1" (2.5 cm) in from each end of the curve in order to leave openings for the handles.
② Make clips along the seam allowance of the curve.
③ Turn the bag right side out. On each side, insert a handle into the opening between the bag and the facing and secure with pins.
④ With right sides together, sew facings to the bag along the top to attach the handles.

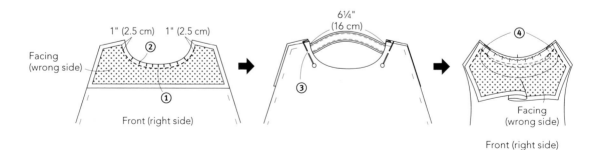

1" (2.5 cm) 1" (2.5 cm)

②

Facing (wrong side)

①

Front (right side)

6¼" (16 cm)

③

④

Facing (wrong side)

Front (right side)

E. Make the gussets.

① Press fusible interfacing to the wrong side of each gusset lining.
② With right sides together, layer each gusset lining, gusset, and batting. Sew along the top.
③ Trim excess, leaving a ¼" (0.6 cm) seam allowance along top and bottom of gusset.
④ Quilt with vertical lines ⅜" (0.8 cm) apart.

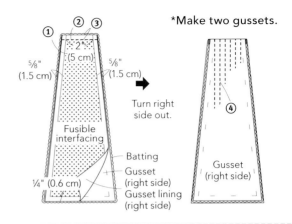

*Make two gussets.

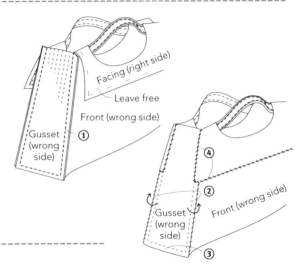

Turn right side out.

2" (5 cm)
⅝" (1.5 cm)
⅝" (1.5 cm)
Fusible interfacing
¼" (0.6 cm)
Batting
Gusset (right side)
Gusset lining (right side)
Gusset (right side)

F. Attach the gussets to the bag.

① With right sides together, sew a gusset to each end of the bag.
② Following the instructions on page 69, finish the seams by wrapping and hemstitching the gusset seam allowances to the bag lining.
③ Press the gusset seam allowances towards the bag bottom.
④ Hemstitch the facings to the bag lining.

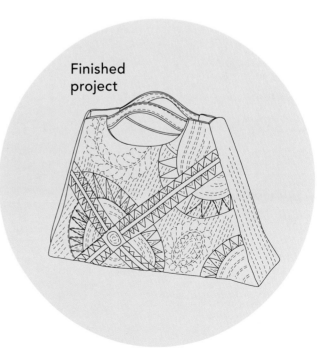

Facing (right side)
Leave free
Front (wrong side)
Gusset (wrong side)
Gusset (wrong side)
Front (wrong side)

G. Attach the bottom lining to the bag.

① Press fusible interfacing to the wrong side of the bottom lining.
② Fold the seam allowances and press with the iron. On the inside of the bag, hemstitch the bottom lining to the bag lining.

① Bottom lining (wrong side) 4" (9.7 cm)
15" (38 cm)

Finished project

B. Finish the pockets.

① Hemstitch pocket piece B to pocket piece C.
② Hemstitch pocket piece B to pocket piece A.

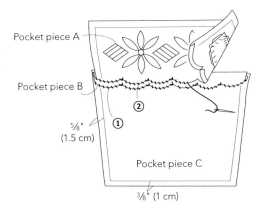

Pocket piece A

Pocket piece B

⅝" (1.5 cm) ① ②

Pocket piece C

⅜" (1 cm)

***Make four pockets.**

C. Attach the pockets.

① With right sides together, sew the four pockets into a combined pocket piece. Press the seam allowances open. Cut the batting and pocket lining into the shape of the combined pocket piece. Layer the pocket piece, batting, and pocket lining. Quilt as desired.
② With right sides together, sew the pocket piece into a tube (refer to page 69 to finish seam allowances).
③ Sew the pocket bias strip into a tube the size of the pocket piece tube.
④ With right sides together, sew the bias strip tube to the top edge of the pocket piece tube, using a ⅜" (0.8 cm) seam allowance.
⑤ Wrap the bias strip around the seam allowance and hemstitch to the pocket lining.

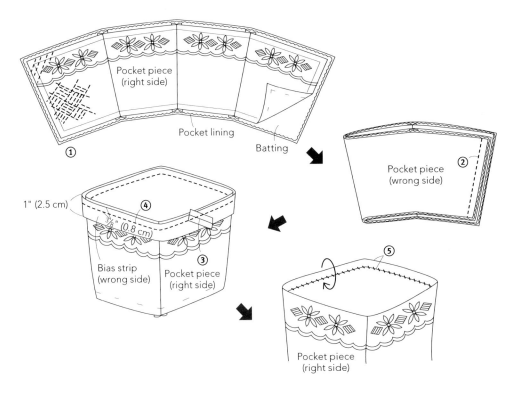

Pocket piece
(right side)

Pocket lining

Batting

①

Pocket piece
(wrong side)

②

1" (2.5 cm)

④

⅜" (0.8 cm)

Bias strip
(wrong side)

Pocket piece
(right side)

③

⑤

Pocket piece
(right side)

D. Make the handle attachments.

① Press lightweight fusible interfacing to the wrong side of one handle attachment piece.
② With right sides together, sew interfaced handle attachment piece, uninterfaced handle attachment piece, and batting, using a ¼" (0.6 cm) seam allowance. Trim excess batting.
③ Turn right side out and topstitch along edges.

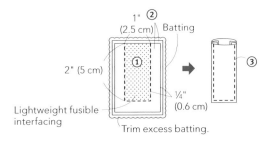

*Make two handle attachments.

E. Make the bag.

① Layer the bag top, batting, and bag lining. Draw quilting lines at 45-degree angles about ⅜" (1 cm) apart and quilt. Make two quilted bag tops.
② Press a ¾" (2 cm) wide piece of heavyweight fusible interfacing to the wrong side of each quilted bag top along the opening edge.
③ With right sides together, sew two bag tops into a tube (refer to page 69 to finish seam allowances).
④ Topstitch the handle attachments to the bag side seams along the top edges only.
⑤ Sew the bag opening bias strip into a tube the size of the bag opening.
⑥ With right sides together, sew the bias strip tube to the top edge of the bag top opening, using a ⅜" (1 cm) seam allowance.
⑦ Wrap the bias strip around the seam allowance and hemstitch to the bag lining.
⑧ On the right side, topstitch the bias strip along the edges.

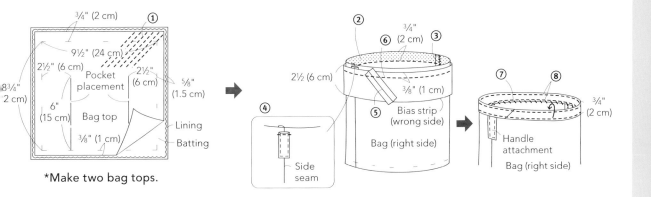

*Make two bag tops.

F. Attach the pocket and bag bottom.

① On the right side, topstitch the pocket piece to the bag in between each pocket.
② Following the instructions on page 73, attach the bag bottom and bottom lining.

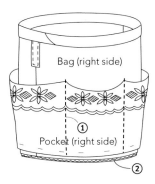

G. Attach the handle.

① Thread handle attachments through holes in the handle and hemstitch to the bag.

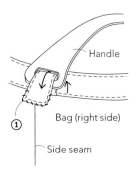

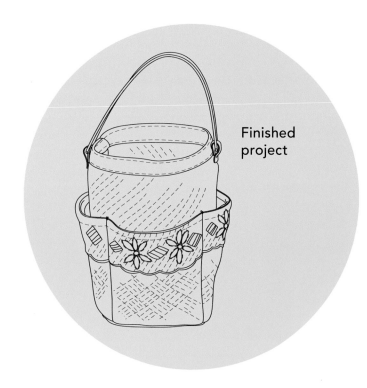

Finished project

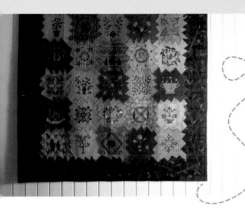

⑨ Baltimore Quilt

Photos on page 20-21

Materials

Appliqué and patchwork fabric:
 Assorted scraps

Border fabric: 43¼" x 70¾"
 (110 x 180 cm)

Backing fabric (for backing, binding,
 and quilt-hanging loop):
 43¼" x 137¾" (110 x 350 cm)

Batting: 70¾" x 70¾" (180 x 180 cm)

Embroidery floss: 1-strand
 embroidery floss

Cut the fabric.

Trace and cut out the templates on Pattern Sheet B.
Using the templates, cut out the appliqué pieces. Cut
out the following pieces, which do not have templates,
according to the measurements below:

✂ Borders: Two 10¾" x 69¼" (27 x 176 cm) border pieces

✂ Borders: Two 10¾" x 49¾" (27 x 126 cm) border pieces

✂ Binding bias strips: 1½" (3.5 cm) wide bias strips

✂ Quilt-hanging loop: One 8" x 67" (20 x 170 cm) piece

A. Make the quilt top.

① Appliqué each block.
② Appliqué blocks together, as shown in the diagram.
③ Appliqué borders.
④ Appliqué quilt top and borders together.
⑤ Embroider each block with colonial knot stitch using
 one strand of embroidery floss (refer to page 95 for
 embroidery instructions).

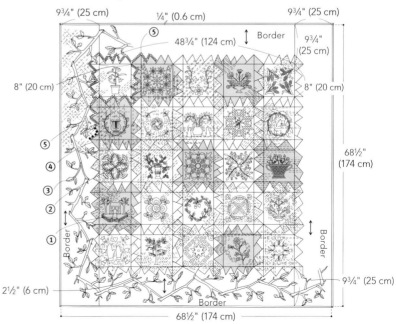

B. Quilt.

① Layer the quilt top, batting, and backing.
② Quilt each block as desired.
③ Quilt the borders, as shown in the diagram.

How to attach batting

Align Whipstitch

You may be able to find king-size batting large enough for this quilt. If you cannot find a single piece of batting large enough, whipstitch two pieces of batting together, as shown in the diagram.

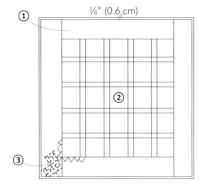

¼" (0.6 cm)

①
②
③

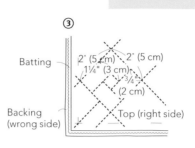

③

Batting

2" (5 cm) 2" (5 cm)
1¼" (3 cm)
¾" (2 cm)

Backing (wrong side) Top (right side)

C. Attach the binding.

① With right sides together, sew bias strips to the quilt, using a ¼" (0.6 cm) seam allowance.
② Wrap the bias strip around the seam allowance and hemstitch to the backing.

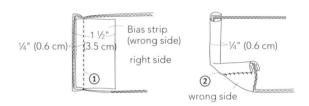

¼" (0.6 cm) 1 ½" (3.5 cm) Bias strip (wrong side) ¼" (0.6 cm)

right side

① ② wrong side

D. Make the quilt-hanging loop.

① Fold the short edges over twice and stitch to finish the raw edges.
② With wrong sides together, sew the long edges to make a loop.
③ Position the loop with the seam allowance on the bottom, as shown in the diagram. Hemstitch the loop to the backing 1"-1¼" (2.5-3 cm) from the top binding and ⅜"-¾" (1-2 cm) from the left and right bindings.
④ Fold the loop so the top meets the binding and press. Hemstitch the bottom of the loop to the backing.
⑤ Hemstitch the sides of the loop to the backing, stitching through the bottom layer only.

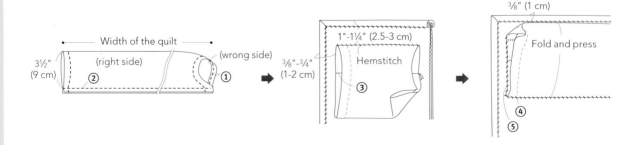

Width of the quilt
3½" (9 cm) (right side) (wrong side)
② ①

⅜"-¾" (1-2 cm)

1"-1¼" (2.5-3 cm)
Hemstitch
③

⅜" (1 cm)
Fold and press
④
⑤

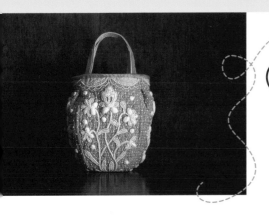

⑩ Candlewick Bag

Photos on pages 22-23

Materials

Appliqué fabric: Assorted scraps

Main fabric (for front, back, and sides): 13¾" x 31½" (35 x 80 cm)

Handle fabric (for handle and handle bias tape): 9¾" x 11¾" (25 x 30 cm)

Bias fabric (for bag opening): One 1¾" x 21¾" (4.5 x 55 cm) bias strip

Lining fabric (for front and back linings, side linings, and lining bias strip): 13¾" x 43¼" (35 x 110 cm)

Batting: 13¾" x 31½" (35 x 80 cm)

Fusible interfacing (for handles): 1½" x 13¾" (3.5 x 30 cm)

Suede ribbon: 23½" (60 cm) of ⅜" (1 cm) wide suede ribbon

Thread: Candlewicking thread or 6-strand embroidery floss

Cut the fabric.

Trace and cut out the templates on Pattern Sheet C. Using the templates, cut out the appliqué pieces, front, back, front lining, back lining, bag sides, and side linings. Cut out the following pieces, which do not have templates, according to the measurements below:

✂ Lining bias strips: Two 1" (2.5 cm) wide bias strips

✂ Bag opening bias strip: One 1¾" x 21¾" (4.5 x 55 cm) bias strip

✂ Handle pieces: Four 1¼" x 11¾" (2.8 x 30 cm) pieces

✂ Handle bias tape: Two small pieces of 1½" (3.5 cm) wide bias tape

- -

A. Make the bag front and back.

① Appliqué, as shown in the diagram.
② Embroider and candlewick, as shown in the diagram (refer to pages 95 for embroidery instructions and 88 for candlewicking instructions).
③ Layer the top, batting, and lining. Draw quilting lines at 45-degree angles about ½" (1.2 cm) apart and quilt.

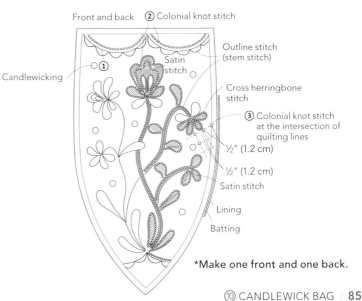

Front and back ② Colonial knot stitch

Candlewicking

①

Satin stitch

Outline stitch (stem stitch)

Cross herringbone stitch

③ Colonial knot stitch at the intersection of quilting lines

½" (1.2 cm)

½" (1.2 cm)

Satin stitch

Lining

Batting

*Make one front and one back.

B. Make the bag sides.

① Appliqué, as shown in the diagram.
② Embroider and candlewick, as shown in the diagram (refer to pages 95 for embroidery instructions and 88 for candlewicking instructions).
③ Layer the top, batting, and lining. Draw quilting lines at 45-degree angles about ½" (1.2 cm) apart and quilt.

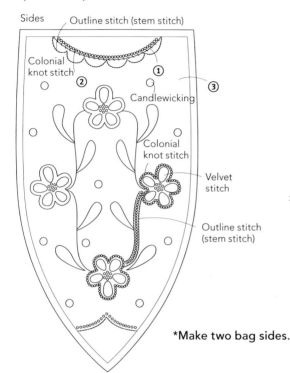

Sides
Outline stitch (stem stitch)
Colonial knot stitch
① ② ③
Candlewicking
Colonial knot stitch
Velvet stitch
Outline stitch (stem stitch)

*Make two bag sides.

C. Attach front and side and back and side.

① With right sides together, sew front and side, using a ⅝" (1.5 cm) seam allowance. Leave one lining seam allowance at ⅝" (1.5 cm), but trim the others.
② Sew one tuck on the side.
③ Hemstitch the tuck seam allowance to the side lining.

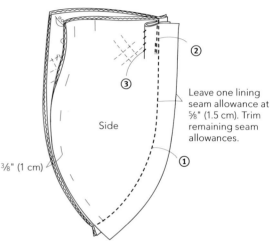

② ③
Leave one lining seam allowance at ⅝" (1.5 cm). Trim remaining seam allowances.
Side
① ③
⅜" (1 cm)

*Repeat Steps 1-3 for back and other side.

D. Sew the bag together.

① Wrap the ⅝" (1.5 cm) lining seam allowances around the other seam allowances and hemstitch to the lining.
② With right sides together, sew the two bag pieces together.
③ Sew the remaining two tucks on the sides.
④ Hemstitch the tuck seam allowances to the side linings.
⑤ With right sides together, sew the lining bias strips to the unfinished seam allowances.
⑥ Wrap the bias strips around the seam allowances and hemstitch to the lining.

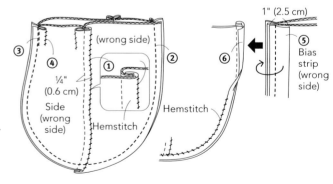

③ ④ ① ② ⑥
(wrong side)
¼" (0.6 cm)
Side (wrong side)
Hemstitch
Hemstitch
1" (2.5 cm)
⑤
Bias strip (wrong side)

E. Finish the bag opening.

① With right sides together, sew the bag opening bias strip to the bag opening.
② Wrap the bias strip around the seam allowance and hemstitch to the lining.

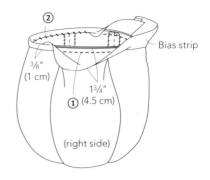

② ① Bias strip

3/8" (1 cm)

1¾" ① (4.5 cm)

(right side)

F. Attach the handles.

① Press fusible interfacing to the wrong side of a handle piece.
② With right sides together, sew one interfaced handle piece to one uninterfaced handle piece. Turn right side out.
③ Cut the suede ribbon in half to make two 11¾" (30 cm) long pieces. Layer a piece of suede ribbon on top of the handle and topstitch along the long edges.
④ On the inside of the bag, position the handle according to the template. Hemstitch a small piece of handle bias tape to the lining, covering the bottom ⅝" (1.5 cm) of each end of the handle.
⑤ Topstitch on the right side to secure handle in place.

*Repeat Steps 1-5 for the other handle.

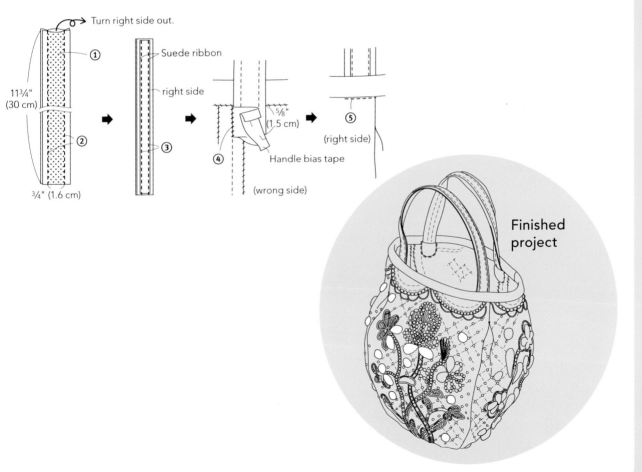

Turn right side out.

①

11¾" (30 cm)

②

¾" (1.6 cm)

Suede ribbon

right side

③

⅝" (1.5 cm)

④

Handle bias tape

(wrong side)

⑤

(right side)

Finished project

How to candlewick

① From the right side, insert the needle through the fabric. Do not make a knot. Instead, leave a ⅜" (1 cm) thread tail.
② Draw the needle out about ¹⁄₃₂" (0.1 cm) to the left of the first stitch.
③ Make a ⅜" (1 cm) loop and insert the needle back through the thread tail and the fabric. This will secure the thread in place.
④ Draw the needle out a little to the left of the first loop and make another ⅜" (1 cm) loop.
⑤ Continue making ⅜" (1 cm) loops to fill in the pattern.
⑥ Cut all the loops.
⑦ Loosen the twist of the thread using a needle.
⑧ Trim into desired shape.

Candlewicking thread (or 6-strand embroidery floss)

Insert the needle through the thread and fabric.

(right side)

①

③ Leave ⅜" (1 cm) thread tail.

¹⁄₃₂" (0.1 cm)

②

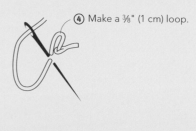

④ Make a ⅜" (1 cm) loop.

⑤ Continue to make ⅜" (1 cm) loops to fill in the pattern.

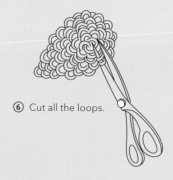

⑥ Cut all the loops.

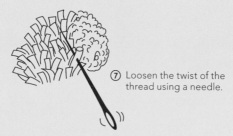

⑦ Loosen the twist of the thread using a needle.

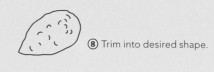

⑧ Trim into desired shape.

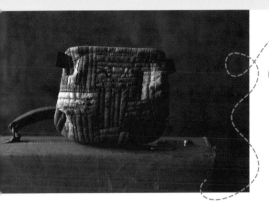

⑪ String Quilt Pouch

Photo on page 24

Materials

Patchwork fabric: Assorted scraps

Main fabric (for back):
 7¾" x 9¾" (20 x 25 cm)

Bias strip fabric (for bag opening):
 One 1" x 13¾ (2.5 x 35 cm) bias strip

Lining fabric (for front and back linings
 and lining bias strip):
 9¾" x 27½" (25 x 70 cm)

Tab fabric: 2¼" x 3½" (5.5 x 9 cm)

Batting: 9¾" x 19¾" (25 x 50 cm)

Zipper: One 5" (12.5 cm) zipper

Cut the fabric.

Trace and cut out the templates on Pattern Sheet B. Using the templates, cut out the patchwork pieces, back, front lining, and back lining. Cut out the following pieces, which do not have templates, according to the measurements below:

✂ Tab pieces: Two 1¾" x 2¼" (4.2 x 5.2 cm) pieces

✂ Lining bias strip: One 1" (2.5 cm) wide bias strip

✂ Bag opening bias strip: One 1" x 13¾" (2.5 x 35 cm) bias strip

A. Make the bag front and back.

① For the front, sew the patchwork pieces together to create the blocks. Sew the blocks together following the order indicated on the template.
② Layer the front, batting, and lining. Baste.
③ Quilt, as shown in the diagram.
④ Stitch in the ditch, as shown in the diagram.
⑤ Trim excess batting, leaving a ⅜" (1 cm) seam allowance.

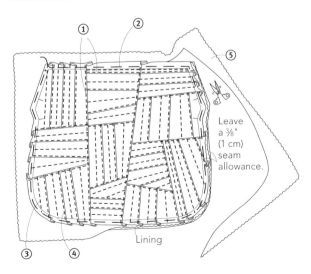

Leave a ⅜" (1 cm) seam allowance.

Lining

B. Make the bag back.

① Layer the back, batting, and lining. Baste.
② Quilt, as shown in the diagram, to create ½" x ¾" (1.2 x 2 cm) rectangles.

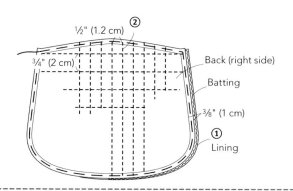

½" (1.2 cm) ②

¾" (2 cm)

Back (right side)

Batting

⅜" (1 cm)

①

Lining

C. Make the tabs.

① Fold the tab piece in half widthwise with right sides together and sew. Turn right side out.
② Center the seam allowance and press.
③ Fold tab in half lengthwise and baste.

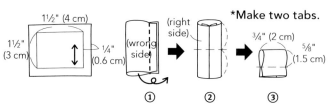

1½" (4 cm)

1½" (3 cm)

¼" (0.6 cm)

(wrong side)

(right side)

(wrong side)

*Make two tabs.

¾" (2 cm)

⅝" (1.5 cm)

① ② ③

D. Sew the bag together.

① On the front, fold tucks and baste.
② Baste the tabs to the right side of the front.
③ With right sides together, sew front and back along sides and bottom.

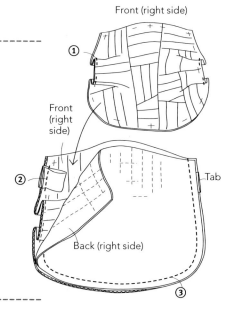

Front (right side)

①

Front (right side)

②

Tab

Back (right side)

③

E. Finish the seam allowances.

① On the inside of the bag, sew the lining bias strip to the front seam allowance.
② Wrap the bias strip around the seam allowance and hemstitch to the back.

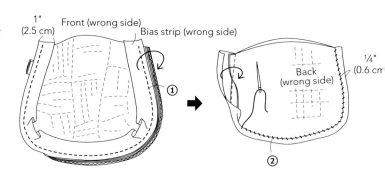

1" (2.5 cm)

Front (wrong side)

Bias strip (wrong side)

①

¼" (0.6 cm

Back (wrong side)

②

F. Install the zipper.

① On the inside of the bag, position the zipper about $\frac{1}{16}$" (0.2 cm) from the bag opening. Backstitch the zipper to the back lining using a $\frac{1}{4}$" (0.6 cm) seam allowance from the edge of the bag. Layer the zipper ends at the bag sides.

② Attach the other side of the zipper to the front following the same process.

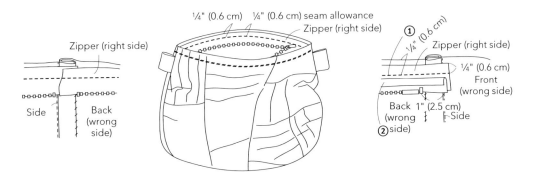

Zipper (right side)

$\frac{1}{4}$" (0.6 cm) $\frac{1}{4}$" (0.6 cm) seam allowance
Zipper (right side)

① $\frac{1}{4}$" (0.6 cm)

Zipper (right side)

$\frac{1}{4}$" (0.6 cm)
Front (wrong side)

Side Back (wrong side)

Back 1" (2.5 cm) (wrong side) Side

② side)

G. Finish the bag opening.

① Sew the bag opening bias strip into a tube the size of the bag opening.

② With right sides together, sew the bias strip to the bag using a $\frac{1}{4}$" (0.6 cm) seam allowance.

③ Fold the bias strip so the seam aligns with the top of the bag and press. Wrap the bias strip around the seam allowance and hemstitch to the zipper.

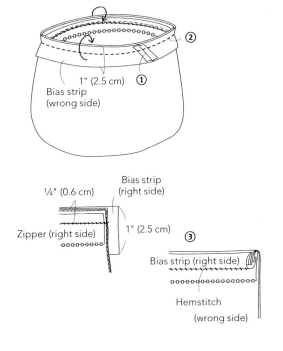

②

1" (2.5 cm) ①
Bias strip (wrong side)

$\frac{1}{4}$" (0.6 cm) Bias strip (right side)

Zipper (right side)

1" (2.5 cm) ③

Bias strip (right side)

Hemstitch (wrong side)

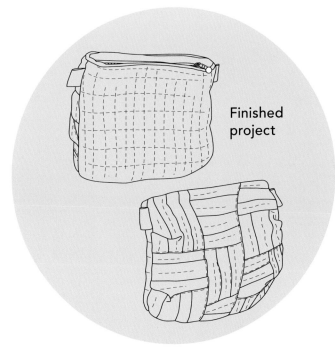

Finished project

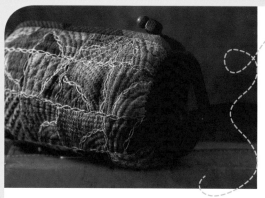

⑫ Drunkard's Path Pouch

Photo on page 25

Materials

Patchwork fabric: Assorted scraps

Bias strip fabric (for bag opening): 1½" x 8¾" (3.5 x 22 cm) bias strip

Tab fabric: 2¼" x 4" (6 x 10 cm)

Handle fabric: 6" x 7" (15 x 18 cm)

Lining fabric (for bag lining, side panel linings, and lining bias strips): 9¾" x 23½" (25 x 60 cm)

Batting: 9¾" x 23½" (25 x 60 cm)

Zipper: One 6¾" (17 cm) zipper

Cording: Small amount of waxed cording

Beads:
One ½" (1.2 cm) diameter round wooden bead
One ½" (1.2 cm) square wooden bead

Embroidery floss: 6-strand embroidery floss

Cut the fabric.

Trace and cut out the templates on Pattern Sheet C. Using the templates, cut out the bag patchwork pieces, bag lining, side panel patchwork pieces, and side panel linings. Cut out the following pieces, which do not have templates, according to the measurements below:

- ✂ Bag opening bias strip: One 1½" x 8¾" (3.5 x 22 cm) bias strip
- ✂ Small tab: One 1" x 1½" (2.5 x 3.5 cm) piece
- ✂ Large tab: One 1¼" x 1½" (3 x 4 cm) piece
- ✂ Handle pieces: Two 1½" x 5¼" (3.5 x 13.2 cm) pieces
- ✂ Lining bias strips: Two 1" x 11¾" (2.5 x 30 cm) bias strips

- -

A. Make the bag top.

① Sew the bag patchwork pieces together (refer to page 108 for piecing curves).
② Embroider, as shown in the diagram (refer to page 95 for embroidery instructions).
③ Layer bag top, batting, and lining. Quilt as desired.

Embroidery order:

First → Embroider outline stitch over chain stitch here.
Outline stitch (1-strand)
② Chain stitch (3-strands)
Second → Embroider outline stitch under chain stitch here.

③ ①

B. Finish the bag opening and install the zipper.

① With right sides together, sew the bag opening bias strip to one short edge of the bag top.
② Wrap the seam allowance with the bias strip and hemstitch to the lining.
③ With right sides together, sew one side of the zipper to the other short edge of the bag top, using a ¹⁄₁₆" (0.2 cm) seam allowance. Trim excess seam allowance and hemstitch zipper to the lining.
④ Fold the bag into a tube and align the short edges so the zipper is hidden. Baste.
⑤ Backstitch the other side of the zipper to the lining beneath the binding, stitching though the lining only so the seam doesn't appear on the outside.
⑥ Hemstitch the zipper to the lining.
⑦ Divide the bag into four equal sections and mark.
⑧ Sew both edges with a running stitch and gather into 10¼" (26 cm).

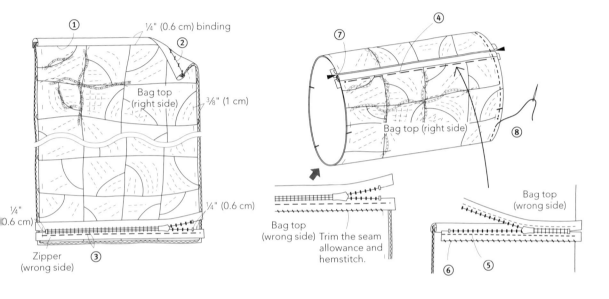

¼" (0.6 cm) binding
Bag top (right side)
³⁄₈" (1 cm)
¼"(0.6 cm)
¼" (0.6 cm)
Zipper (wrong side)
Bag top (right side)
Bag top (wrong side) Trim the seam allowance and hemstitch.
Bag top (wrong side)

C. Attach the tabs.

① Fold both tab pieces in half widthwise and sew using a ¼" (0.6 cm) seam allowance.
② Turn right side out and press.
③ Fold, as shown in the diagrams and press. Topstitch. Position the small tab on the inside of the bag and the large tab on the outside and attach.

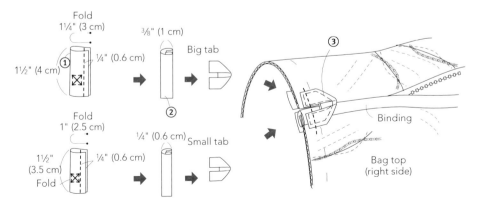

Fold
1¼" (3 cm)
³⁄₈" (1 cm)
¼" (0.6 cm)
Big tab
1½" (4 cm)
Fold
1" (2.5 cm)
¼" (0.6 cm)
Small tab
1½" (3.5 cm)
Fold
¼" (0.6 cm)
Binding
Bag top (right side)

D. Make the side panels and handle.

① Sew the side panel patchwork pieces together. Layer each side panel, batting, and side panel lining. Quilt as desired.
② With right sides together, sew handle pieces and batting along long edges.
③ Trim excess batting and turn right side out. Topstitch.
④ Sew handle to a side panel.

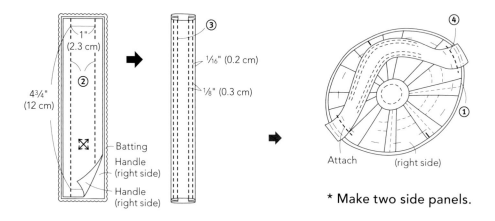

1"
(2.3 cm)

②

4¾"
(12 cm)

Batting
Handle
(right side)
Handle
(right side)

③

¹⁄₁₆" (0.2 cm)

⅛" (0.3 cm)

④

Attach (right side)

①

* Make two side panels.

E. Sew the bag together.

① With right sides together, sew side panels to the bag top at each end, making sure that the markers align.
② With right sides together, sew a lining bias strip to each side panel seam allowance. Wrap seam allowances with bias strips and hemstitch.
③ Embroider the side panels with colonial knot stitches and attach the beads to the zipper.

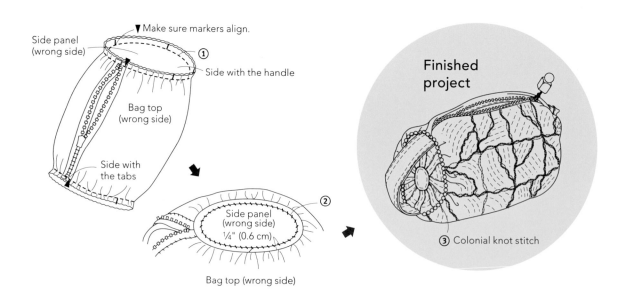

▼ Make sure markers align.

Side panel
(wrong side)

①

Side with the handle

Bag top
(wrong side)

Side with
the tabs

Side panel
(wrong side)
¼" (0.6 cm)

②

Bag top (wrong side)

Finished
project

③ Colonial knot stitch

Embroidery Guide

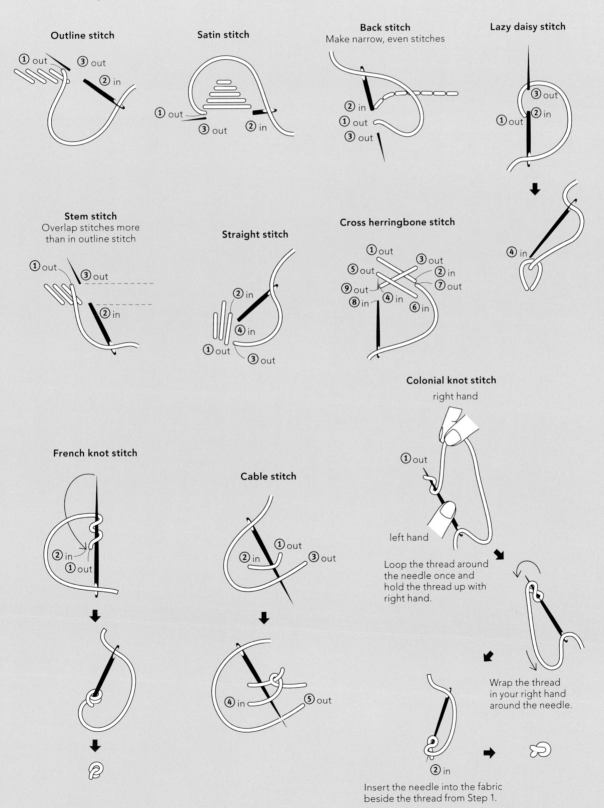

Outline stitch

① out ③ out
② in

Satin stitch

① out
③ out ② in

Back stitch
Make narrow, even stitches

② in
① out
③ out

Lazy daisy stitch

③ out
② in
① out

④ in

Stem stitch
Overlap stitches more
than in outline stitch

① out ③ out
② in

Straight stitch

② in
④ in
① out ③ out

Cross herringbone stitch

① out ③ out
⑤ out ② in
⑨ out ⑦ out
⑧ in ④ in ⑥ in

French knot stitch

② in
① out

Cable stitch

① out
② in ③ out

④ in ⑤ out

Colonial knot stitch
right hand

① out

left hand

Loop the thread around
the needle once and
hold the thread up with
right hand.

Wrap the thread
in your right hand
around the needle.

② in

Insert the needle into the fabric
beside the thread from Step 1.

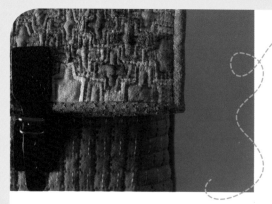

⑬ Shoulder Bag with Crosses

Photos on pages 26-27

Materials

Appliqué fabric: Assorted scraps

Main fabric (for front and flap): 17¾" x 23½" (45 x 60 cm)

Back fabric: 12" x 12" (30.5 x 30.5 cm)

Lining fabric: 19¾" x 23½" (50 x 60 cm)

Bias strip fabric (for bag opening): Two 1½" x 19¾" (3.5 x 50 cm) bias strips

Lining bias fabric: One 1½" x 43¼" (3.5 x 110 cm) bias strip

Batting: 19¾" x 23½" (50 x 60 cm)

String (for loops): 4" (10 cm) of ⅛" (0.4 cm) thick string

Strap: One ⅝" (1.5 cm) wide leather shoulder strap with metal swivel hooks

Belt: One leather belt with metal buckle

Cut the fabric.

Trace and cut out the templates on Pattern Sheet C. Using the templates, cut out the appliqué pieces, flap, front, front lining, and back lining. Cut out the following pieces, which do not have templates, according to the measurements below:

✂ Back: One 9½" x 9¾" (24 x 25 cm) piece

✂ Bag opening bias strips: Two 1½" x 19¼" (3.5 x 50 cm) bias strips

✂ Lining bias strip: One 1½" x 43¼" (3.5 x 110 cm) bias strip

- -

A. Appliqué the crosses to the bag flap.

① For each cross, fold the seam allowance under using the needle tip and blind hemstitch the cross to the bag flap so that the stitching is invisible from the right side. Stop ¼" (0.6 cm) before each corner, make a clip in the cross seam allowance, then continue stitching.

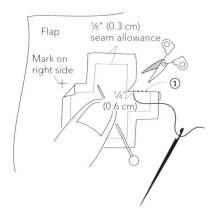

B. Make the bag back.

① With right sides together, sew the flap and back piece.
② Layer the back, batting, and back lining. Baste from the center towards the outside.
③ Quilt the crosses as shown in the diagram, using a machine or backstitching by hand.
 Draw quilting lines and machine quilt to make ½" x ½" (1.2 x 1.2 cm) squares on the back piece.
④ With right sides together, sew a bag opening bias strip to the opening edge of the flap.
⑤ Wrap the seam allowance with the bias strip and hemstitch to the lining.

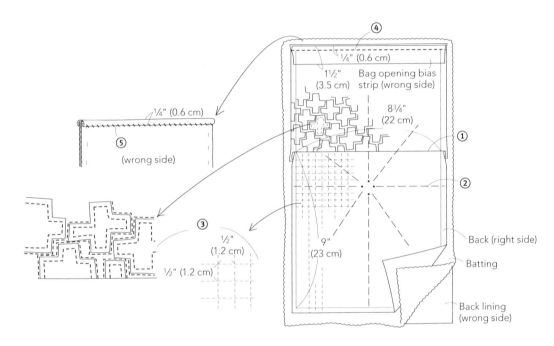

C. Make the bag front.

① Layer the bag front, batting, and front lining. Baste from the center towards the outside, in the same manner as the bag back. Draw quilting lines and machine quilt to make ½" x ½" (1.2 x 1.2 cm) squares.
② Sew darts. Press seam allowances towards the center and hemstitch to the lining. Trim the excess.
③ Finish opening edge of bag front using the other bag opening bias strip in the same manner as the flap.

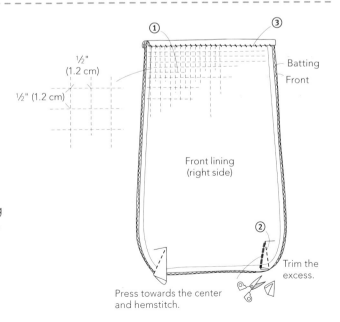

D. Sew the bag together.

① Make loops using 2" (5 cm) of string and baste one to each side of bag back below flap.
② Align front and back with wrong sides together. Sew the lining bias strip to the bag back, stitching through all three layers.
③ Wrap seam allowance with bias strip and hemstitch to the bag front.
④ Fold bias strip seam allowance under and hemstitch at the bag opening.

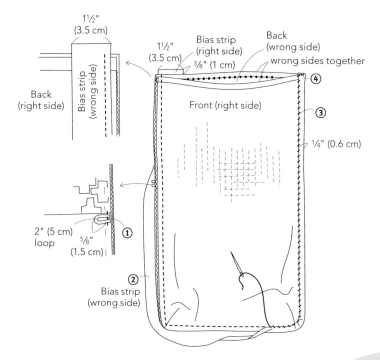

E. Attach the strap and buckle.

① Fold bag flap down and clip leather strap to loops.
② Cut buckle components off of belt and topstitch to bag. See finished project diagram for buckle placement.

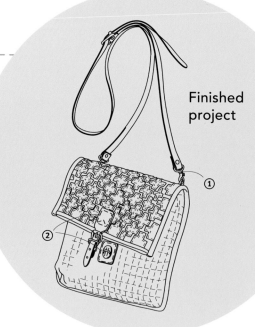

Finished project

⑭ Appliqué Quilt Tapestry

Photos on pages 28-29

Materials

Patchwork, appliqué, and decorative
 trim fabric: Assorted scraps

Edge fabric: 43¼" x 70¾" (110 x 180 cm)

Border fabric: 43¼" x 47¼"
 (110 x 120 cm)

Backing fabric (for backing, binding,
 and quilt-hanging loop):
 43¼" x 181" (110 x 460 cm)

Batting (for quilt and decorative
 trim pieces): 70¾" x 74¾"
 (180 x 190 cm)

Cut the fabric.

Trace and cut out the templates on Pattern Sheet B.
Using the templates, cut out the appliqué pieces. Cut
out the following pieces, which do not have templates,
according to the measurements below:

✂ Border pieces: Two 14¾" x 30¼" (37.5 x 77 cm) pieces
 and two 14¾" x 54¼" (37.5 x 137.5 cm) pieces

✂ Edge pieces: Two 9¾" x 69¾" (25 x 177 cm) pieces
 and two 9¾" x 44¼" (25 x 112.5 cm) pieces

✂ Decorative trim pieces:
 Several ⅞"-1½" x 1¾"-2¼" (2.1-3.6 x 4.2-5.2 cm) pieces

✂ Binding bias strips: 1½" (2.5 cm) wide bias strips

- -

A. Make the quilt top.

① Appliqué each block.
② Sew the blocks together, as shown in the diagram.
③ Attach the borders and edge pieces to quilt top.
④ Appliqué the borders and edge pieces.
⑤ Layer top, batting, and backing. Quilt as desired.
 You may need to seam your batting and backing
 (refer to page 84 for instructions on seaming batting).

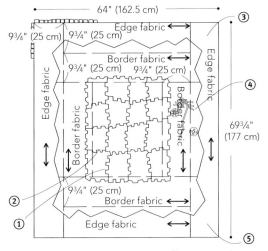

B. Attach the decorative trim and binding.

① For each piece, layer two decorative trim pieces and batting with right sides together and sew along three sides using a ¼" (0.6 cm) seam allowance.

② Turn right side out and topstitch along three sides using a ¼" (0.6 cm) seam allowance.

③ With right sides together, arrange the decorative trim pieces along the edges of the quilt and secure in place. Sew the binding bias strips to the quilt, stitching through the decorative edge pieces.

④ Wrap the seam allowance with the bias strip and hemstitch to the backing.

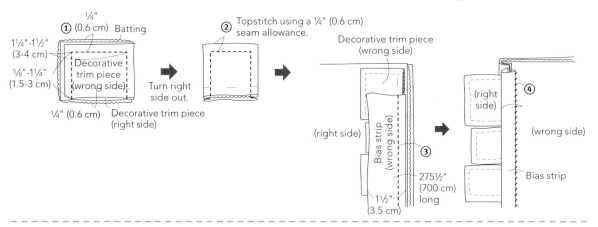

C. Finish the quilt.

① Use scraps to appliqué square pieces to the edge fabric as desired. Make the quilt-hanging loop and attach it to the backing (refer to page 84 for instructions).

① Appliqué

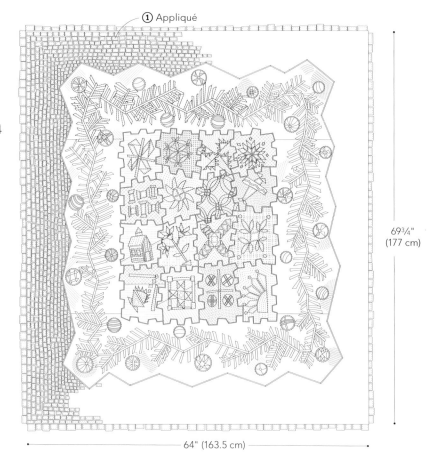

69¾" (177 cm)

64" (163.5 cm)

⑮ Compass Bag

Photo on page 30

Materials

Appliqué fabric: Assorted scraps

Top fabric: 15¾" x 31½" (40 x 80 cm)

Bottom fabric: 8" x 13¾" (20 x 35 cm)

Accent fabric (for piping, opening
 edge facings, bag opening bias strip,
 handle attachments, and bottom bias
 strip: 35½" x 39½" (90 x 100 cm)

Lining fabric (for bag lining and bottom
 bias strips): 15¾" x 43¼" (40 x 110 cm)

Batting: 15¾" x 39¼" (40 x 100 cm)

Fusible interfacing (for inside facing):
 12¾" x 23½" (32.5 x 60 cm)

Piping cord: 31½" (80 cm) of ⅛"
 (0.3 cm) thick piping cord

Handles: One set of handles with an
 inner width of 2" x 4" (5 x 10.5 cm)

Cut the fabric.

Trace and cut out the templates on Pattern Sheet C. Using the templates, cut out the appliqué pieces, bottom, and bottom lining. Cut out the following pieces, which do not have templates, according to the measurements below:

✂ Bag tops: Two 11¾" x 14¼" (30 x 36 cm) pieces

✂ Bag linings: Two 11¾" x 15¾" (30 x 40 cm) pieces

✂ Piping: Twenty-two 1" (2.5 cm) wide bias strips

✂ Bottom bias strips: Two 1" x 31½" (2.5 x 80 cm) bias strips

✂ Inside facing: One 1¾" x circumference of bag opening (about 23¾") (4.5 x circumference of bag opening [about 60.5 cm]) piece

✂ Outside facing: One 1¾" x circumference of bag opening (about 23¾") (4.5 x circumference of bag opening [about 60.5 cm])

✂ Opening edge bias strip: One 1" (2.5 cm) wide bias strip

✂ Handle attachment pieces: Four 3½" x 4¼" (9 x 10.5 cm) pieces.

- -

A. Make the piping for the bag tops.

① With right sides together, fold the 1" (2.5 cm) wide bias strips in half and stitch.

② Turn right side out and center the seam allowance. Press.

③ Repeat Steps 1-2 to make twelve ¼" x 6¼" (0.6 x 16 cm) and ten ¼" x 13" (0.6 x 33 cm) piping strips.

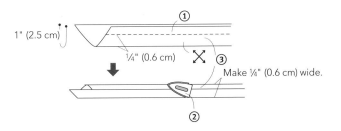

1" (2.5 cm) ¼" (0.6 cm) ③
Make ¼" (0.6 cm) wide.

B. Make the bag tops.

① Appliqué the compasses, then hemstitch the compasses and the piping strips to the bag tops, as shown in the diagram.
② Layer the bag tops, batting, and lining. Quilt as desired. Leave the lining seam allowances at ¾" (2 cm).
③ With right sides together, sew the two bag tops together along both side seams. Wrap the ¾" (2 cm) lining seam allowances around the other seam allowances and hemstitch to finish the side seams (refer to page 69).

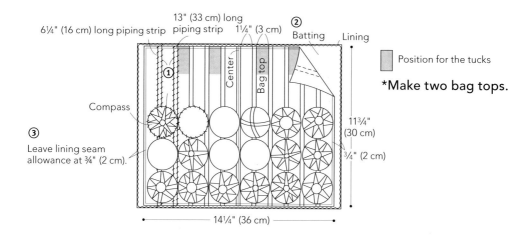

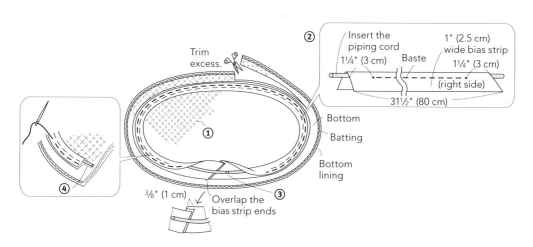

C. Make the bag bottom.

① Layer the bottom, batting, and bottom lining. Draw quilting lines at 45-degree angles about ⅝" (1.5 cm) apart and quilt.
② Make the bottom piping by folding one bottom bias strip in half with piping cord sandwiched in between. Baste close to the cord.
③ Baste piping to the bottom, trimming cord to correct length and overlapping the bias strip ends to create a finished edge.
④ Trim excess seam allowance and sew bottom to bag with right sides together. Finish the seam allowance using the other bottom bias strip.

D. Finish the bag opening.

① Sew eight tucks.
② Make opening edge facings (inside and outside): For the outside facing, layer batting on the wrong side and for the inside facing, press fusible interfacing to the wrong side.
③ Sew the outside facing and batting into a ring by stitching together along the short edges. Sew the inside facing into a ring by stitching together along the short edges.
④ With right sides together, sandwich the bag between the inside and outside facings and sew around the opening edge.
⑤ Turn facings up, press, and quilt, as shown in the diagram
⑥ With right sides together, sew the opening edge bias strip to the outside facing, using a ¼" (0.6 cm) seam allowance and stitching through both facings.
⑦ Wrap the bias strip around the seam allowances.
⑧ Hemstitch the bias strip to the inside facing.

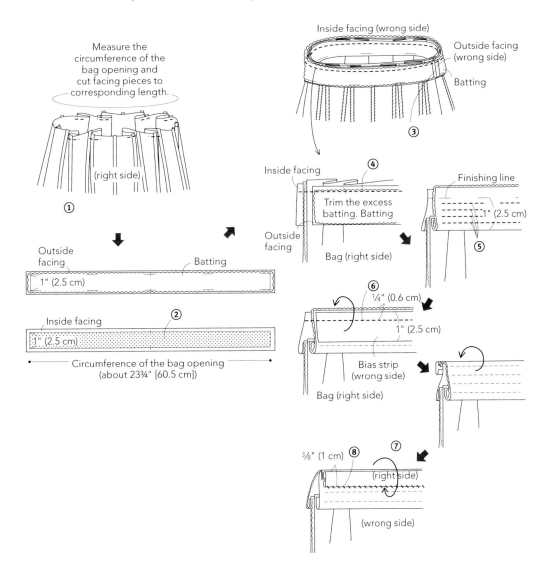

E. Attach the handles.

① Fold a handle attachment piece in half lengthwise with right sides together and sew along the short edges.
② Turn right side out and topstitch along sides and bottom.
③ Align the handle attachment as shown in the diagram and backstitch to inside facing.
④ Insert the handle, fold the handle attachment down, and hemstitch to inside facing. Repeat Steps 1-4 for other handle.

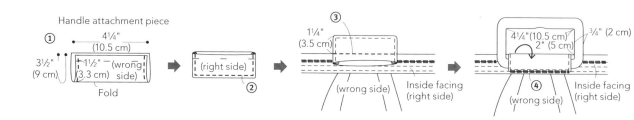

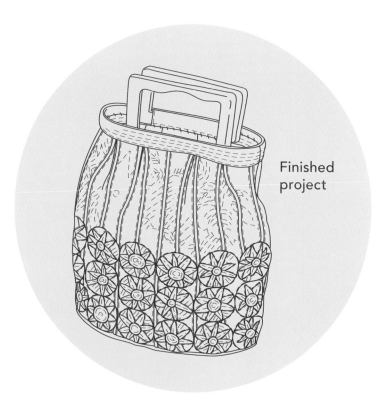

Finished project

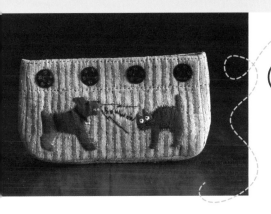

⑯ Pouch with Dog & Cat Appliqué

Photo on page 31

Materials

Appliqué fabric: Assorted scraps

Main fabric (for bag front, back, and gusset): 8" x 15¾" (20 x 40 cm)

Lining fabric (for front and back linings, gusset linings, and facing): 9¾" x 17¾" (25 x 45 cm)

Batting: 4" x 15¾" (10 x 40 cm)

Buttons: Eight ¾" (1.8 cm) diameter buttons

Snaps: Four sets of ⅝" (1.6 cm) diameter snaps

Embroidery floss: 6-strand embroidery floss

Cut the fabric.

Trace and cut out the templates on Pattern Sheet C. Using the templates, cut out the appliqué pieces, front, front lining, back, back lining, gusset, gusset lining, and facing.

- -

A. Make the bag sides.

① Appliqué and embroider the bag front and back (refer to page 95 for embroidery instructions).
② Layer the bag front, batting, and lining. Stitch in the ditch around the appliqué. Quilt with vertical lines, about ¼"-⅜" (0.6-1 cm) apart.
③ Layer the bag back, batting, and lining. Quilt with vertical lines, about ¼"-⅜" (0.6-1 cm) apart.

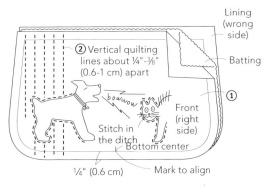

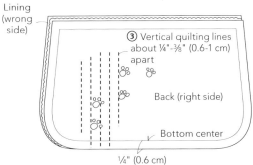

B. Make the bag gusset.

① Press fusible interfacing to the wrong side of the gusset lining. Layer gusset, batting, and gusset lining. Quilt with horizontal lines about ¼" (0.6 cm) apart. Do not trim the seam allowances.

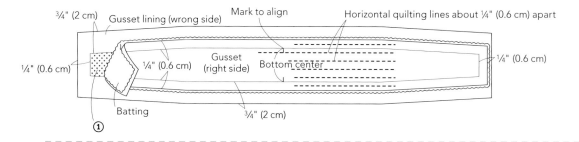

¾" (2 cm)　Gusset lining (wrong side)　Mark to align　Horizontal quilting lines about ¼" (0.6 cm) apart

¼" (0.6 cm)

Gusset
(right side)

Bottom center

¼" (0.6 cm)

¼" (0.6 cm)

Batting

¾" (2 cm)

①

C. Sew the bag together.

① With right sides together, sew the gusset to the bag front and back.
② Wrap the gusset lining seam allowance around the other seam allowances and hemstitch to the lining.

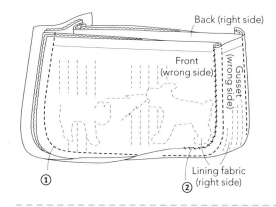

Back (right side)

Front
(wrong side)

Gusset
(wrong side)

Lining fabric
(right side)

①

②

D. Attach the facing.

① Press fusible interfacing to the wrong side of each facing piece.
② With right sides together, sew facing pieces along short sides. Press seam allowances open.
③ Make facing into finished size by folding and pressing the bottom seam allowance. Measure the bag opening and adjust facing size if necessary.
④ With right sides together, sew facing to the bag along the opening edge.
⑤ Turn facing right side out and fold to the inside of the bag.

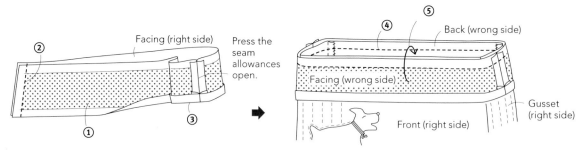

②

Facing (right side)

Press the
seam
allowances
open.

③

①

⑤

④

Back (wrong side)

Facing (wrong side)

Front (right side)

Gusset
(right side)

E. Attach the facing.

① Hemstitch facing to the bag lining.
② Topstitch facing on the right side by making a running stitch using two strands of embroidery floss.

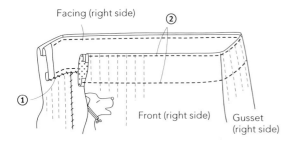

Facing (right side)

②

①

Front (right side)

Gusset (right side)

F. Attach the buttons and snaps.

① Sew four buttons to the bag back, as shown in the diagram. On the inside, attach the four female snap components in the same position as the buttons.
② Repeat Step 1 for the bag front, using the remaining buttons and the male snap components.

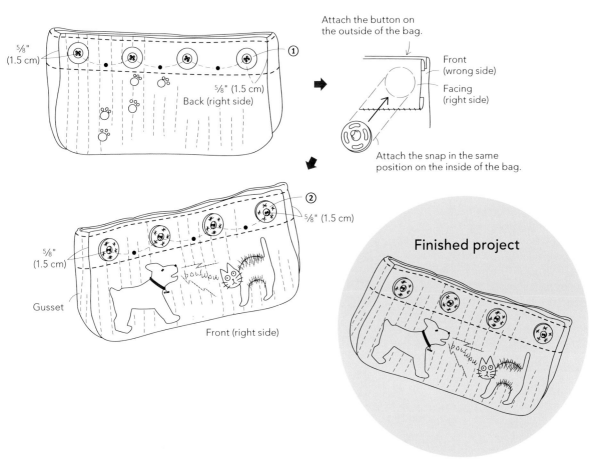

⅝" (1.5 cm)

①

⅝" (1.5 cm)

Back (right side)

Attach the button on the outside of the bag.

Front (wrong side)

Facing (right side)

Attach the snap in the same position on the inside of the bag.

②

⅝" (1.5 cm)

⅝" (1.5 cm)

Gusset

Front (right side)

Finished project

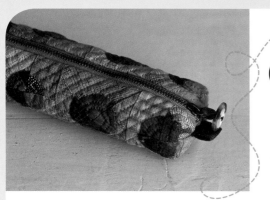

⑰ Circle Pen Case

Photo on page 32

Materials

Patchwork fabric: Assorted scraps

Tab fabric: 2¼" x 3½" (5.5 x 9 cm)

Accent fabric (for lining bias strips and zipper charm): 4" x 4" (10 x 10 cm)

Lining fabric: 8" x 11¾" (20 x 30 cm)

Stuffing: Small amount of polyester/cotton stuffing

Zipper: One 8" (20.5 cm) zipper

Button: One ⅞" (2.2 cm) diameter button

Cut the fabric.

Trace and cut out the templates on Pattern Sheet C. Using the templates, cut out the patchwork pieces and case lining. Cut out the following pieces, which do not have templates, according to the measurements below:

✂ Tab pieces: Two 1¾" x 2¼" (4.2 x 5.2 cm) bias strips

✂ Lining bias strips: 1½" (3.5 cm) wide bias strips

✂ Zipper charm piece: One 1¼" x 1½" (2.7 x 3.7 cm) bias strip

A. Make the case top.

① Mark each rectangular patchwork piece and cut into two pieces along the curve.

② With right sides together, align marks and sew the pieces together along the curve, using a ¼" (0.6 cm) seam allowance.

③ Press the seam allowance toward the curved piece.

④ Sew all 48 pieces together to make the case top.

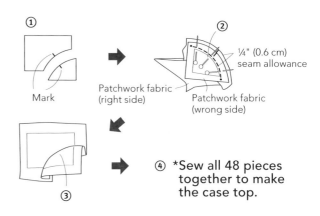

① Mark

Patchwork fabric (right side)

② ¼" (0.6 cm) seam allowance

Patchwork fabric (wrong side)

③

④ *Sew all 48 pieces together to make the case top.

B. Quilt the case.

① Layer the case top, batting, and lining.
② Quilt two evenly spaced circles inside each patchwork circle.
③ Stitch in the ditch outside each patchwork circle.
④ Draw quilting lines at 45-degree angles about ¼" (0.6 cm) apart and quilt.

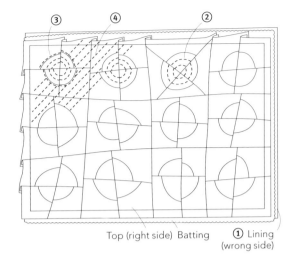

Top (right side) Batting ① Lining (wrong side)

C. Install the zipper.

① Position the zipper so it starts and stops ¼" (0.6 cm) in from each end of the case.
② With right sides together, sew the zipper to each long side of the case using a ¼" (0.6 cm) seam allowance.
③ Fold the raw edge of the zipper under and hemstitch to the lining.

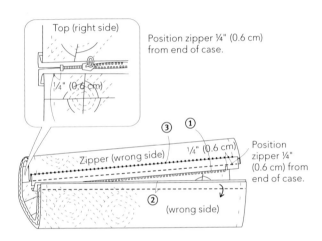

Top (right side)

Position zipper ¼" (0.6 cm) from end of case.

¼" (0.6 cm)

③ ① ¼" (0.6 cm)

Position zipper ¼" (0.6 cm) from end of case.

Zipper (wrong side)

② (wrong side)

D. Attach the tabs.

① With right sides together, fold a tab piece in half widthwise and sew using a ¼" (0.6 cm) seam allowance. Press the seam allowance open.
② Turn right side out and center the seam allowance. Fold the tab in half lengthwise.
③ Sandwich the tab between the two layers of the case and sew.

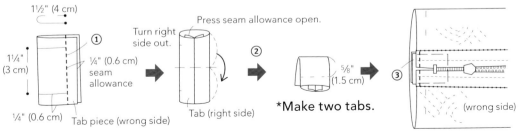

1½" (4 cm)

1¼" (3 cm)

① ¼" (0.6 cm) seam allowance

¼" (0.6 cm) Tab piece (wrong side)

Turn right side out.

Press seam allowance open.

②

Tab (right side)

⅝" (1.5 cm)

③

*Make two tabs.

(wrong side)

*Repeat Steps 1-3 to attach the second tab to the other side in the same way.

E. Finish the seam allowances.

① With right sides together, sew a lining bias strip to a short side of the case using a ¼" (0.6 cm) seam allowance.
② Wrap the bias strip around the seam allowance and hemstitch to the lining.
③ Miter each corner. With right sides together, sew a lining bias strip to each corner using a 1¼" (3 cm) long seam.
④ Trim the excess seam allowance and fold in the raw edges of the bias strip.
⑤ Wrap the bias strip around the seam allowance and hemstitch to the lining.

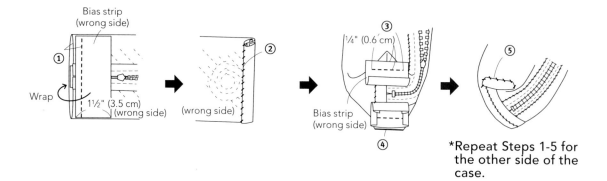

*Repeat Steps 1-5 for the other side of the case.

F. Make the zipper charm.

① With right sides together, fold the zipper charm piece in half widthwise and sew using a ¼" (0.6 cm) seam allowance.
② Turn right side out and fill with a small amount of stuffing.
③ Thread the zipper charm piece through the zipper pull and hemstitch the edges together to make a loop.
④ Attach the button.

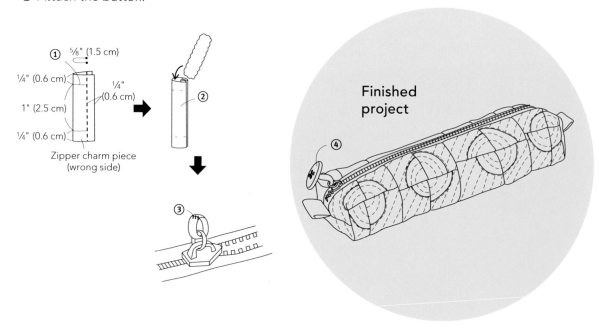

Finished project

⑱ Pouch with Reverse Appliqué

Photo on page 33

Materials

Appliqué fabric: Assorted scraps

Main fabric (for bag sections):
7" x 19¾" (18 x 50 cm)

Bias fabric (for handle):
1¼" x 8" (3 x 20 cm)

Lining fabric: 8" x 19¾" (20 x 50 cm)

Batting: 8" x 19¾" (20 x 50 cm)

Zipper: One 4¾" (12 cm) zipper

Buttons: Two ½" (1.2 cm) diameter
buttons

Embroidery floss: 6-strand
embroidery floss

Cut the fabric.

Trace and cut out the templates on Pattern Sheet C. Using the templates, cut out the appliqué pieces, bag centers, center linings, bag sides, and side linings. Cut out the following piece, which does not have a template, according to the measurements below:

✄ Handle piece: One 1¼" x 8" (3 x 20 cm) bias strip

How to sew reverse appliqué

① Trace the template and draw a ⅛" (0.3 cm) seam allowance. Cut out along the template lines.
② Make clips in the seam allowance.
③ Align the appliqué fabric underneath main fabric.
④ Baste the appliqué fabric in place using a ¼" (0.6 cm) seam allowance.
⑤ Fold the seam allowance under using the needle tip.
⑥ Hemstitch.

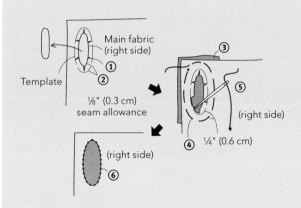

A. Appliqué and embroider the bag sections.

① Appliqué and reverse appliqué, as shown in the diagram.
② Embroider, as shown in the diagram (refer to page 95 for embroidery instructions).

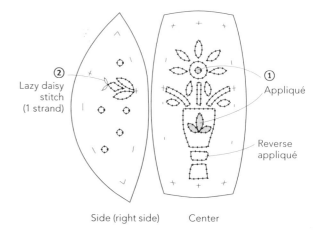

Side (right side) Center

*Make two centers and four sides.

B. Assemble the bag sections.

① With right sides together, layer each section, lining and batting. Sew, leaving openings to turn right side out.
② Trim excess seam allowance, turn right side out, and hemstitch the openings closed.

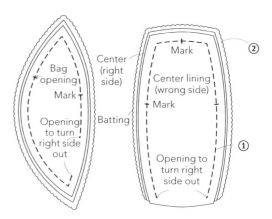

C. Quilt the bag sections.

① Stitch in the ditch around appliqué.
② Quilt as desired.

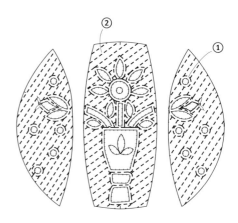

*Be sure to quilt the second set of bag sections.

D. Sew the bag sections together.

① With right sides together, sew two sides to each center section using a narrow whipstitch.

*Sew the other bag sections together in the same way.

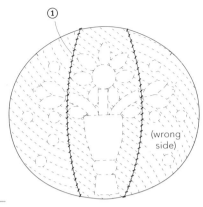

(wrong side)

E. Install the zipper and sew the bag together.

① Machine stitch the zipper to each side of the bag, using a ¼" (0.6 cm) seam allowance.
② Hemstitch the zipper to the lining.
③ Sew the bag together at the sides using a narrow whipstitch.

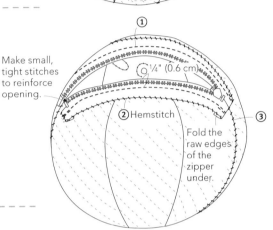

Make small, tight stitches to reinforce opening.

¼" (0.6 cm)

② Hemstitch

Fold the raw edges of the zipper under.

F. Attach the handle.

① With right sides together, fold the handle piece in half widthwise and sew along bottom and one long side, using a ¼" (0.6 cm) seam allowance. Turn right side out and topstitch along long sides.
② Thread the handle through the zipper pull and overlap the ends about ⅜" (1 cm) to form a loop. Hemstitch the overlapped sections together.
③ Attach the buttons.

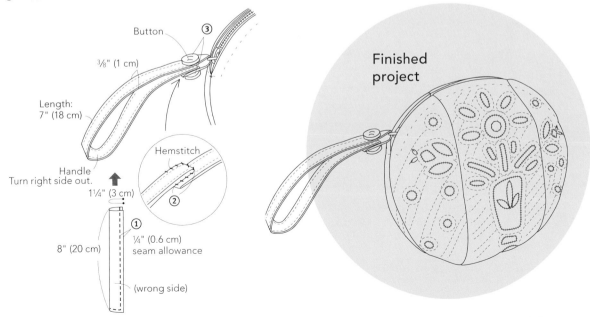

Button

⅜" (1 cm)

Length: 7" (18 cm)

Handle
Turn right side out.

1¼" (3 cm)

8" (20 cm)

Hemstitch

¼" (0.6 cm) seam allowance

(wrong side)

Finished project

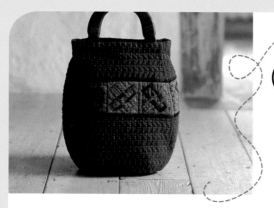

⑲ Square Cross Bag

Photo on page 34

Materials

Appliqué fabric: Assorted scraps

Patchwork fabric (A-C):
 4" x 8" (10 x 20 cm) each

Patchwork fabric (D & E):
 4" x 6" (10 x 15 cm) each

Main fabric (for front, back, gussets,
 and facing): 11¾" x 43¼"
 (30 x 110 cm)

Bottom fabric (for bottom and bias
 strips): 11¾" x 19¾" (30 x 50 cm)

Handle attachment fabric:
 8" x 8" (20 x 20 cm)

Lining fabric: 15¾" x 43¼"
 (40 x 110 cm)

Batting: 15¾" x 43¼" (40 x 110 cm)

Fusible interfacing (for handle
 attachments and bottom linings):
 6" x 19¾" (15 x 50 cm)

Handles: One set of handles with
 an inner width of 3¾" (9.5 cm)

Cut the fabric.

Trace and cut out the templates on Pattern Sheet C. Using the templates, cut out the appliqué pieces, patchwork pieces, front and back sections, front lining, back lining, gusset sections, and gusset linings. Cut out the following pieces, which do not have templates, according to the measurements below:

✂ Bias strips: ⅞" (2.1 cm) wide bias strips

✂ Bottom: One 4½" x 6¾" (11.2 x 16.7 cm) piece

✂ Bottom linings: Two 4½" x 6¾" (11.2 x 16.7 cm) pieces

✂ Handle attachment pieces: Eight 1½" x 2¾" (3.7 x 7 cm) pieces

✂ Facing: One 1½" (3.4 cm) x circumference of bag opening bias strip

- -

A. Appliqué the bag.

Patchwork fabric (right side)

Appliqué fabric
(right side)

A. Appliqué the bag (continued).

① Mark the appliqué placement on the patchwork fabric.
② Prepare appliqué fabric #1: Cut out appliqué fabric #1 with a ⅛" (0.3 cm) seam allowance around the center and outside edge. Clip the corners along the center seam allowance and mark the position where appliqué fabric #2 will overlap.
③ Prepare appliqué fabric #2: Cut out appliqué fabric #2 with a ⅛" (0.3 cm) seam allowance around the center and outside edge. Clip the corners along the center seam allowance and mark the position where appliqué fabric #1 will overlap. Make a cut in the center of one overlap area.
④ Position the appliqué fabrics on the patchwork fabric. Overlap the appliqué fabrics as shown in the diagram, making sure to position the cut edges of appliqué fabric #2 underneath appliqué fabric #1. Fold the appliqué fabric seam allowances under.
⑤ Hemstitch the appliqué fabrics to the patchwork fabric.

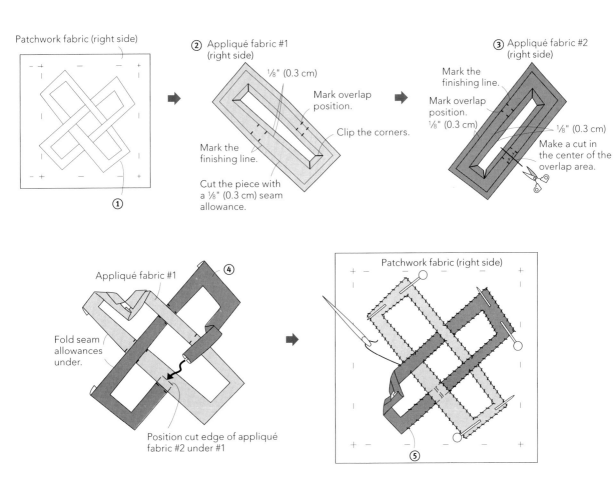

Patchwork fabric (right side)

①

② Appliqué fabric #1 (right side)
⅛" (0.3 cm)
Mark overlap position.
Clip the corners.
Mark the finishing line.
Cut the piece with a ⅛" (0.3 cm) seam allowance.

③ Appliqué fabric #2 (right side)
Mark the finishing line.
Mark overlap position.
⅛" (0.3 cm)
⅛" (0.3 cm)
Make a cut in the center of the overlap area.

④ Appliqué fabric #1
Fold seam allowances under.
Position cut edge of appliqué fabric #2 under #1

⑤ Patchwork fabric (right side)

B. Sew the patchwork pieces together.

① For both the bag front and back, sew patchwork pieces (A-C) together using a ¼" (0.6 cm) seam allowance. With right sides together, sew a bias strip along the top and bottom of the patchwork pieces. Sew bias strips to patchwork pieces D and E in the same manner for the gussets.

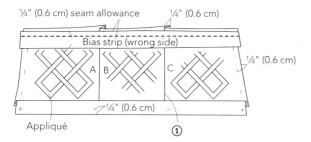

¼" (0.6 cm) seam allowance ¼" (0.6 cm)

Bias strip (wrong side)

¼" (0.6 cm)

A B C

¼" (0.6 cm)

Appliqué

①

C. Quilt the gussets, front, and back.

① For each gusset, attach top and bottom sections to bias strips. Layer gusset, batting, and gusset lining. Quilt, as shown in the diagram. Stitch in the ditch around the appliqué and bias strips. Leave the lining seam allowance ¾"-1" (2-2.5 cm) along the sides.
② For the front, attach top and bottom sections to bias strips.
③ Layer the front, batting, and lining. Baste.
④ Quilt, as shown in the diagram. Stitch in the ditch around the appliqué and bias strips and quilt the patchwork pieces as desired.

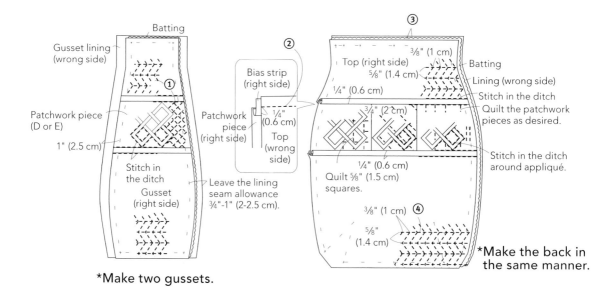

Batting

Gusset lining (wrong side)

①

Patchwork piece (D or E)

1" (2.5 cm)

Stitch in the ditch

Gusset (right side)

*Make two gussets.

Bias strip (right side)

Patchwork piece (right side)

¼" (0.6 cm)

Top (wrong side)

Leave the lining seam allowance ¾"-1" (2-2.5 cm).

②

③

⅜" (1 cm)

Top (right side)

⅝" (1.4 cm)

¼" (0.6 cm)

Batting

Lining (wrong side)

Stitch in the ditch

Quilt the patchwork pieces as desired.

¾" (2 cm)

¼" (0.6 cm)

Quilt ⅝" (1.5 cm) squares.

⅜" (1 cm) ④

⅝" (1.4 cm)

Stitch in the ditch around appliqué.

*Make the back in the same manner.

D. Sew darts on the front and back.

① Sew darts.
② Hemstitch the dart seam allowances to the lining.

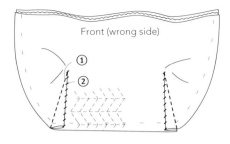

Front (wrong side)

①
②

Sew the back in the same manner.

E. Make the bottom.

① Press fusible interfacing the wrong side of the bottom lining.
② Layer the bottom, batting, and bottom lining. Baste.
③ Draw quilting lines at 45-degree angles about ½" (1.2 cm) apart and quilt.

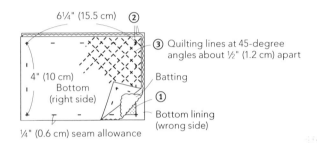

6¼" (15.5 cm) ②

③ Quilting lines at 45-degree angles about ½" (1.2 cm) apart

4" (10 cm)
Bottom (right side)

Batting
①
Bottom lining (wrong side)

¼" (0.6 cm) seam allowance

F. Sew the bag together.

① With right sides together, sew the bottom to the front and back along long sides following finishing lines.
② With right sides together, sew the gussets to the front and back following finishing lines.
③ Wrap the lining seam allowances around the other seam allowances and hemstitch.
④ Sew the gussets to the bottom along short sides. Press the seam allowances toward the bottom.
⑤ Press fusible interfacing to second bottom lining. Position this bottom lining to hide the seam allowances and hemstitch in place.

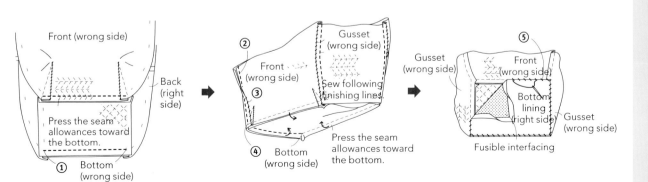

Front (wrong side)

Back (right side)

Press the seam allowances toward the bottom.

① Bottom (wrong side)

②
Front (wrong side)
③

Gusset (wrong side)
Sew following finishing lines.

④ Bottom (wrong side)
Press the seam allowances toward the bottom.

⑤
Gusset (wrong side)
Front (wrong side)
Bottom lining (right side)
Gusset (wrong side)
Fusible interfacing

G. Make the handles.

① Press fusible interfacing to the wrong side of one handle attachment piece. With right sides together, sew one interfaced handle attachment piece to one uninterfaced handle attachment piece. Turn right side out.
② Topstitch the handle attachment along long sides, as shown in the diagram.
③ Thread the handle attachment through the handle holes, fold in half, and baste.

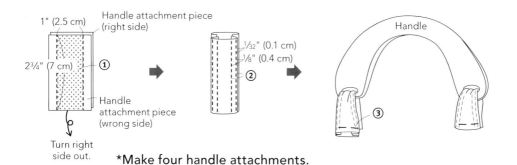

1" (2.5 cm)
Handle attachment piece (right side)
2¾" (7 cm)
①
Handle attachment piece (wrong side)
Turn right side out.
¹⁄₃₂" (0.1 cm)
⅛" (0.4 cm)
②
Handle
③

***Make four handle attachments.**

H. Finish the bag opening.

① Press fusible interfacing to the wrong side of the facing. Sew the short sides of the facing together to create a tube the size of the bag opening. Press the seam allowances open.
② Baste the handle attachments to the bag.
③ With right sides together, sew the facing to the bag opening using a ¼" (0.6 cm) seam allowance. Fold the bottom seam allowance of the facing and press.
④ Fold the facing to the inside and hemstitch to the lining.

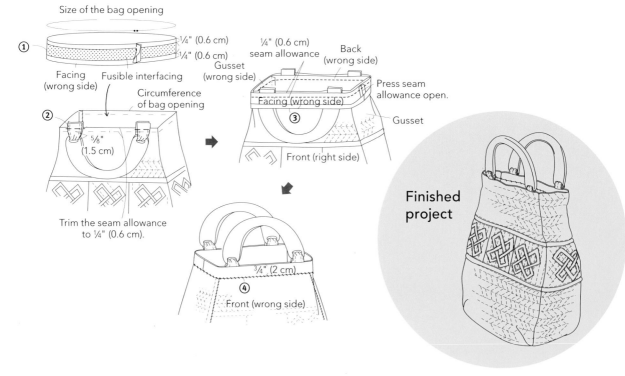

Size of the bag opening
① ¼" (0.6 cm)
¼" (0.6 cm)
Facing (wrong side) Fusible interfacing
Circumference of bag opening
② ⅝" (1.5 cm)
Trim the seam allowance to ¼" (0.6 cm).

¼" (0.6 cm) seam allowance
Back (wrong side)
Gusset (wrong side)
Press seam allowance open.
③
Facing (wrong side)
Gusset
Front (right side)

④ ¾" (2 cm)
Front (wrong side)

Finished project

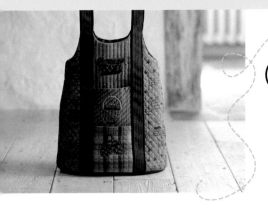

⑳ Bag with Basket Motifs

Photo on page 35

Materials

Appliqué fabric: Assorted scraps

Fabric A (for A pieces):
15¾" x 27½" (40 x 70 cm)

Fabric B (for piece B):
6" x 17¾" (15 x 45 cm)

Fabric C (for lower front piece and
piece C): 6" x 17¾" (15 x 45 cm)

Fabric D (for piece D): 6" x 6" (15 x 15 cm)

Handle fabric: 8" x 39½" (20 x 100 cm)

Bottom fabric: 8" x 13" (20 x 33 cm)

Bottom foundation fabric:
8" x 13" (20 x 33 cm)

Lining fabric (for front and back lining,
facing, and bottom lining):
19¾" x 43¼" (50 x 110 cm)

Batting: 11¾" x 39½" (30 x 100 cm)

Fusible interfacing (for facing,
handles, and bottom):
19¾" x 43¼" (50 x 110 cm)

Nylon webbing: 79" (200 cm) of
1" (2.5 cm) wide nylon webbing

Cut the fabric.

Trace and cut out the templates on Pattern Sheet C. Using the templates, cut out the appliqué pieces, two A pieces, piece B, lower front piece, back, front lining, back lining, piece C, pocket lining C, piece D, pocket lining D, bottom, bottom foundation, and bottom lining. Cut out the following pieces, which do not have templates, according to the measurements below:

✂ Handles: Four 2" x 37¾" (4.7 x 95.6 cm) pieces

- -

A. Appliqué and sew and the bag front pieces together.

① Appliqué the baskets to pieces B, C, and D. Follow the numbers on the templates for the appliqué order.
② With right sides together, sew piece B to the lower front piece. Press the seam allowance open.
③ With right sides together, sew one piece A on each side. Press seam allowances open.

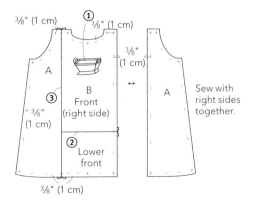

B. Quilt the bag front and back.

① Layer the bag front, batting, and front lining. Baste.
② Quilt each section of the bag front, as shown in the diagram.
③ Layer the bag back, batting, and back lining. Baste.
④ Draw quilting lines at 45-degree angles about ½" (1.2 cm) apart and quilt.

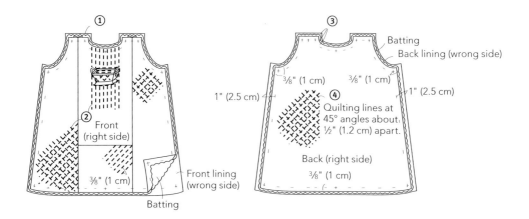

C. Attach the facing.

① Make two facing pieces by tracing the top 1½" (3.5 cm) of the bag front template.
② Press fusible interfacing to the wrong side of each facing piece.
③ Fold the seam allowance and press. Clip curved seam allowance.
④ With right sides together, sew one facing piece to the bag front along the top edge, starting and stopping ¼" (0.6 cm) in from each edge. Clip curved seam allowance and trim excess batting. Turn facing to the inside of the bag.
⑤ Press facing with the iron and baste to the lining

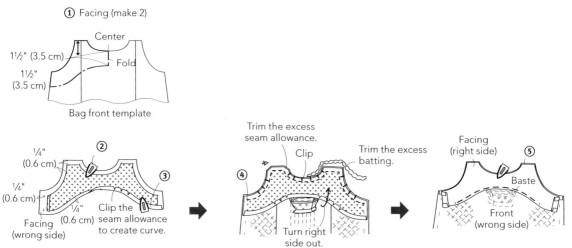

*Attach the other facing piece to the bag back in the same manner.

D. Make the handles.

① Press fusible interfacing to the wrong side of one handle piece. With right sides together, sew one interfaced handle piece to one uninterfaced handle piece along long sides, using a ¼" (0.6 cm) seam allowance. Turn right side out.

② Layer nylon webbing on top of handle and topstitch, as shown in the diagram.

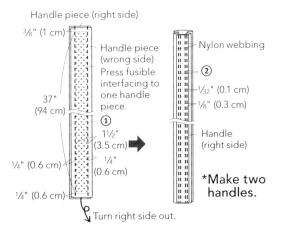

Handle piece (right side)
⅜" (1 cm)
Handle piece (wrong side)
Press fusible interfacing to one handle piece.
37" (94 cm)
Nylon webbing
②
1/32" (0.1 cm)
⅛" (0.3 cm)
Handle (right side)
①
1½" (3.5 cm)
¼" (0.6 cm)
¼" (0.6 cm)
¼" (0.6 cm)
Turn right side out.
*Make two handles.

E. Make the pockets.

① Make the upper pocket: With right sides together, layer batting, pocket lining C, and piece C. Sew along the top and bottom, as shown in the diagram. Trim the excess batting and turn right side out.

② Draw diagonal quilting lines about ⅜" (1 cm) apart and quilt.

③ Using piece D, make the lower pocket in the same manner as the upper pocket.

④ Draw horizontal and vertical quilting lines about ½" (1.2 cm) apart and quilt.

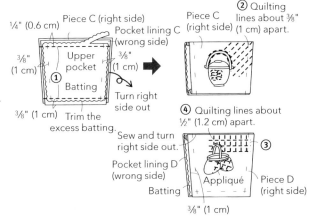

¼" (0.6 cm)
Piece C (right side)
Pocket lining C (wrong side)
⅜" (1 cm)
Upper pocket
⅜" (1 cm)
①
Batting
⅜" (1 cm)
Trim the excess batting.
Turn right side out.
Piece C (right side)
② Quilting lines about ⅜" (1 cm) apart.
④ Quilting lines about ½" (1.2 cm) apart.
Sew and turn right side out.
Pocket lining D (wrong side)
Batting
Appliqué
③
Piece D (right side)
⅜" (1 cm)

F. Attach the pockets and handles.

① Baste the upper pocket in place and hemstitch to the bag front.

② Baste the lower pocket in place.

③ Topstitch the handles to the bag, stitching through the handle fabric.

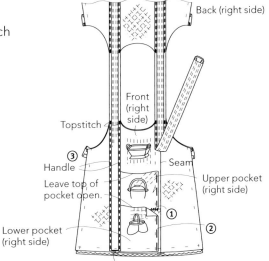

Back (right side)
Front (right side)
Topstitch
③
Handle
Leave top of pocket open.
Seam
Upper pocket (right side)
①
②
Lower pocket (right side)
Align the edge of the handle with the bottom edge of the front.

G. Sew the bag together and finish the seam allowances.

① With right sides together, sew the two facing pieces together along each short side. Press the seam allowances open.
② With right sides together, sew the bag front and back together. Keep the facing away when stitching. Leave the back seam allowance at 1" (2.5 cm).
③ Wrap the back seam allowance around the front seam allowance and hemstitch.
④ Hemstitch the facing to the lining.

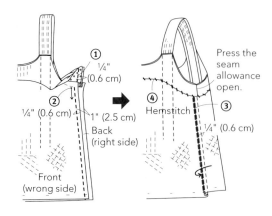

H. Attach the bag bottom.

① Press fusible interfacing to the wrong side of the bottom foundation. Layer bottom, batting, and bottom foundation and baste. Draw quilting lines at 45-degree angles about ½" (1.2 cm) apart and quilt.
② With right sides together, sew bottom to the bag, making sure to align at marks.
③ Make the bottom lining: Press fusible interfacing to the wrong side of the bottom lining. Using a running stitch, gather the seam allowance of the bottom lining to make it the finished size.
④ Hemstitch the bottom lining to the bag lining, hiding seam allowances.

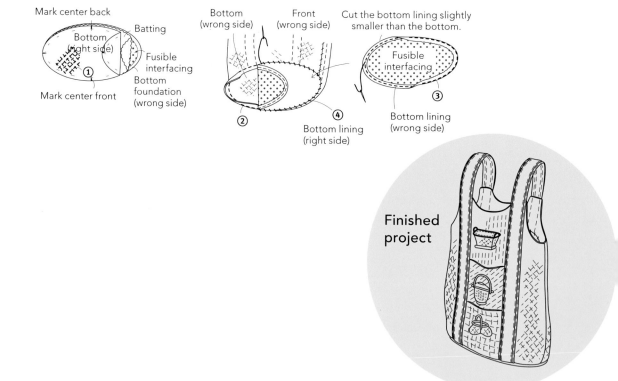

㉑ Sewing Case with Lemon Star Appliqué

Photos on pages 36-37

Materials

Appliqué fabric: Assorted scraps

Top fabric: 9¾" x 13¾" (25 x 35 cm)

Foundation fabric: 9¾" x 13¾" (25 x 35 cm)

Lining fabric 9¾" x 13¾" (25 x 35 cm)

Tab fabric: 4" x 4" (10 x 10 cm)

Inside compartment fabric: Assorted scraps

Bias strip fabric (for piping): One 1" x 39½" (2.5 x 100 cm) bias strip

Fusible interfacing (for tab, scissors pocket, pencil holder, magnetic button, and lining): 8" x 15¾" (20 x 40 cm)

Batting: 9¾" x 13¾" (25 x 35 cm)

Stuffing: Small amount of polyester/cotton stuffing

Hook and loop tape: 1¼" x 1½" (3 x 3.5 cm)

Zippers:
One 3½" (9 cm) zipper
One 3" (7.5 cm) zipper

Piping cord: 39½" (100 cm) of ⅛" (0.3 cm) thick piping cord

Suede cord: 8" (20 cm) of ¼" (0.6 cm) wide suede cord

Waxed cording: Small amount of waxed cording

Zipper charm: One zipper charm

Accent fabric (for fabric loop and cord decoration): 2" x 2" (5 x 5 cm)

Magnetic button: One ½" (1.4 cm) diameter magnetic button set

Decorative button: One ¾" (2 cm) diameter decorative button

Embroidery floss: 6-strand embroidery floss

Cut the fabric.

Trace and cut out the templates on Pattern Sheet D. Using the templates, cut the appliqué pieces, case top, foundation piece, case lining, tab pieces, scissors pocket pieces, pencil holder pieces, small pocket, small pocket lining, large pocket, and large pocket lining. Cut out the following pieces, which do not have templates, according to the measurements below:

✂ Bias strip (for piping): One 1" x 39½" (2.5 x 100 cm) bias strip

✂ Pin cushion piece: One 3¼" x 5" (7.7 x 12.2 cm) piece

✂ Thread holder pieces: One ¾" x 1¼" (1.6 x 2.6 cm) piece and one 1¼" x 1½" (2.6 x 3.2 cm) piece

✂ Fabric loop: One 1" x 2" (2.5 x 5 cm) piece

✂ Cord decoration piece: One ¼" x ½" (0.6 x 1.3 cm) piece

- -

A. Make the case top.

① Applique the case top.
② Embroider the case top (refer to page 95 for embroidery instructions).
③ Layer case top, batting, and foundation piece. Quilt the Lemon Star by stitching inside the points using a ⅛" (0.3 cm) seam allowance and outside the points using a ¹⁄₁₆" (0.2 cm) seam allowance. Quilt the rest of the case top as desired.

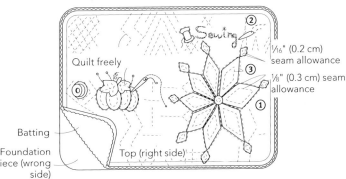

B. Make the piping.

① Sandwich the piping cord inside the bias strip and baste.
② Sew the short edges of the bias strip together to make a tube the size of the area to be trimmed with piping.
③ Sew the ends of the piping cord together.
④ Sandwich the piping cord inside the bias strip with cord seam positioned next to bias strip seam, fold the bias strip in half and baste. With right sides together, baste the piping to the case top.

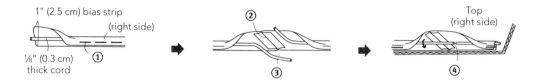

1" (2.5 cm) bias strip
(right side)
⅛" (0.3 cm) thick cord ①
②
③
Top (right side)
④

C. Make the tab.

① Press fusible interfacing to the wrong side of one tab piece. With right sides together, layer batting and two tab pieces. Sew, using a ¼" (0.6 cm) seam allowance. Trim excess batting and turn right side out.
② Topstitch tab, as shown in the diagram.
③ With right sides together, align the center of the tab with the case top and sew around the entire case top.

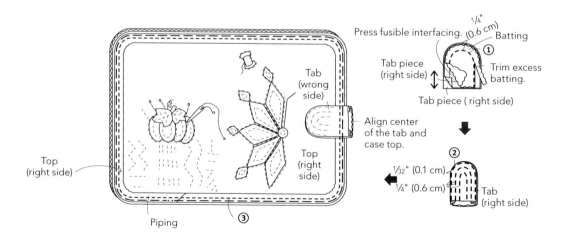

Tab (wrong side)
Top (right side)
Top (right side)
Piping
③

Press fusible interfacing. ¼" (0.6 cm)
Batting
①
Tab piece (right side)
Trim excess batting.
Tab piece (right side)
Align center of the tab and case top.
②
1/32" (0.1 cm)
¼" (0.6 cm)
Tab (right side)

D. Make the inside compartments.

Scissors Pocket

① Press fusible interfacing to the wrong side of one scissors pocket piece. With right sides together, sew interfaced scissors pocket piece to uninterfaced scissors pocket piece, leaving an opening to turn right side out.

② Trim excess seam allowance and points and make clips in the concavely curved seam allowance.

③ Turn right side out and hemstitch the opening closed. Draw vertical quilting lines about ¼" (0.6 cm) apart and quilt.

④ Topstitch around the edges using a ¹⁄₁₆" (0.2 cm) seam allowance.

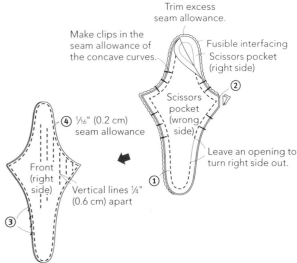

Trim excess seam allowance.

Make clips in the seam allowance of the concave curves.

Fusible interfacing
Scissors pocket (right side)

②

Scissors pocket (wrong side)

④ ¹⁄₁₆" (0.2 cm) seam allowance

Leave an opening to turn right side out.

Front (right side)

①

③

Vertical lines ¼" (0.6 cm) apart

Pin Cushion

① Fold the pin cushion piece in half lengthwise with right sides together. Sew across the top, leaving a 1¼" (3 cm) opening to turn right side out.

② Press seam allowance open and center the seam.

③ Sew both ends using a ¼" (0.6 cm) seam allowance.

④ Miter the corners by folding and sewing a ⅝" (1.5 cm) seam, as shown in the diagram.

⑤ Topstitch along sides.

⑥ Fill the pin cushion with stuffing and hemstitch the opening closed.

⑦ Hemstitch one side of a ¾" x 1" (2 x 2.5 cm) piece of hook and loop tape to the bottom of the pin cushion.

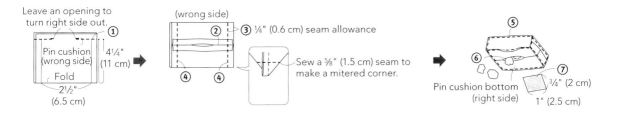

Leave an opening to turn right side out.

①

Pin cushion (wrong side)

4¼" (11 cm)

Fold

2½" (6.5 cm)

(wrong side)

② ③ ¼" (0.6 cm) seam allowance

④ ④

Sew a ⅝" (1.5 cm) seam to make a mitered corner.

⑤

⑥

Pin cushion bottom (right side)

⑦ ¾" (2 cm)

1" (2.5 cm)

Pockets

① Align pocket top and pocket lining with right sides together. Sandwich the zipper between the layers with wrong side facing up, as shown in the diagram. Starting and stopping at the markers, sew through both layers of fabric and the zipper.

② Sew the pocket top and pocket lining together using a ¼" (0.6 cm) seam allowance, leaving a 1¼" (3 cm) opening to turn right side out. When sewing, make sure to pivot at the corners. Make clips in the seam allowance at the corners.

③ Turn right side out and hemstitch the opening closed.

④ Align corners and whipstitch to make the mitered corners.

⑤ Topstitch along sides.

⑥ Align zipper edge and mitered corner and sew together.

*Follow Steps 1-6 for both the small and large pockets.

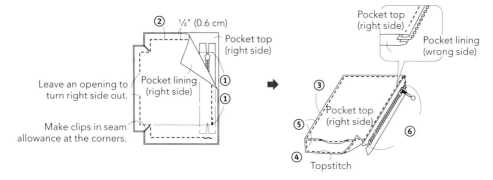

Pencil holder

① Press fusible interfacing to the wrong side of two pencil holder pieces. With right sides together, sew each interfaced pencil holder piece to an uninterfaced pencil holder piece, leaving an opening. Turn right side out.

② Hemstitch the openings closed. Draw vertical quilting lines about ¼" (0.6 cm) apart and quilt.

③ Topstitch around the edges using a ¹⁄₁₆" (0.2 cm) seam allowance.

④ Align the two pieces and machine stitch together at center. Whipstitch the pieces together around edges. Leave the top open.

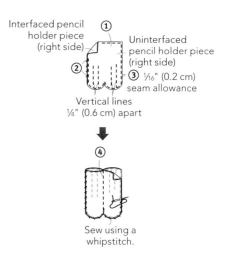

E. Attach the compartments to the case lining.

① Press fusible interfacing to the wrong side of the lining.

② To attach scissors pocket: Hemstitch the bottom of the pocket to the lining. Hemstitch a ⅜" (1 cm) in diameter circle of hook and loop tape to both the pocket and the case lining.

③ To attach the pencil holder: Tack the pencil holder to the lining along the bottom of the pencil holder on the wrong side. Fold the pencil holder up.

④ To attach the pockets: Machine stitch the free side of the zipper to the case lining. Hemstitch the edge of the zipper to the pocket lining. Hemstitch the pocket to the lining along three sides.

⑤ To attach the pin cushion: Sew the remaining ¾" x 1" (2 x 2.5 cm) piece of hook and loop tape to the lining.

⑥ Turn the raw edges of the ¾" x 1¼" (1.6 x 2.6 cm) threadholder piece under. Sandwich a 6" (15 cm) piece of suede cord between this piece and the lining at the top of the case and topstitch. With right sides together, fold the fabric loop piece in half lengthwise and sew. Turn right side out and fold into a loop. Turn the raw edges of the remaining threadholder piece under. Sandwich the loop between this piece and the lining at the bottom of the case and topstitch. Thread the charm onto the waxed cording. Layer the waxed cording on top of the suede cord and wrap the cord decoration piece around the cords. Hemstitch the fabric to the cords.

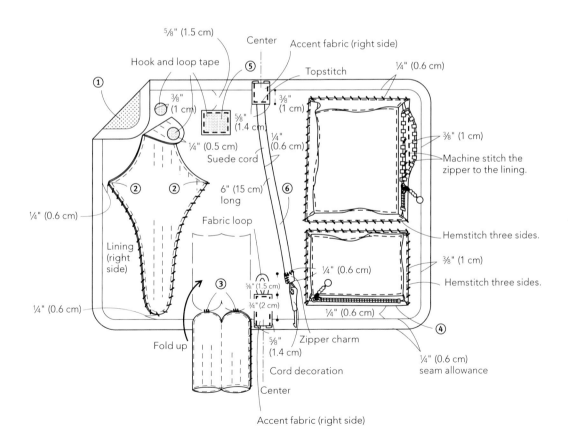

F. Sew the case together.

① With right sides together, sew the top and lining, leaving a 3¼" (8 cm) opening. Turn right side out.

*You may find it difficult to sew the top and lining together and turn right side out due to the presence of the inside compartments. If so, you can just hemstitch the lining to the case top.

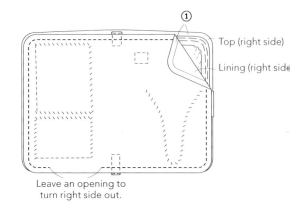

Top (right side)

Lining (right side)

Leave an opening to
turn right side out.

G. Finish the case top.

① Hemstitch the opening closed.

② Press fusible interfacing to the wrong side of a circular piece of lining fabric. Cut two parallel slits in the fabric and sew a running stitch around the outer edge. Insert the male component of the magnetic button through the slits in the fabric circle, then through the metal support. Bend the prongs to secure. Gather the fabric around the magnetic button and hemstitch to the tab on the inside.

③ Follow the same process described in Step 2 to attach the female component of the magnetic button to the case top.

④ Sew a decorative button to the tab.

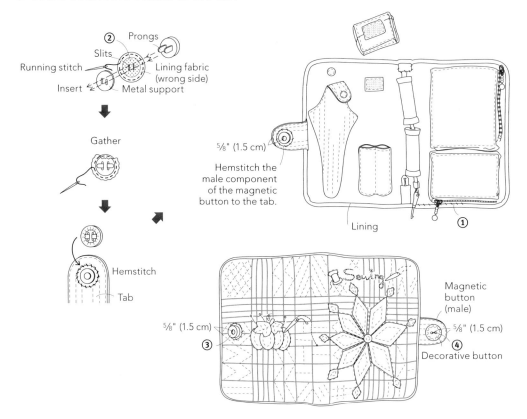

② Prongs
Slits
Running stitch
Insert
Lining fabric
(wrong side)
Metal support

Gather

Hemstitch
Tab

⅝" (1.5 cm)
Hemstitch the
male component
of the magnetic
button to the tab.

Lining

①

Magnetic
button
(male)

⅝" (1.5 cm)

⅝" (1.5 cm)

③

④
Decorative button

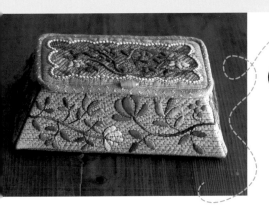

㉒ Small Box with Flower Appliqué

Photo on page 38

Materials

Appliqué fabric: Assorted scraps

Appliqué base fabric (for flap appliqué): 4" x 8" (10 x 20 cm)

Main fabric (for flap and sides): 11¾" x 15¾" (30 x 40 cm)

Bottom fabric: 8" x 11¾" (20 x 30 cm)

Bias strip fabric (for flap binding): 1½" x 23½" (3.5 x 60 cm) bias strip

Lining fabric (for flap and box): 13¾" x 21¾" (35 x 55 cm)

Foundation fabric (for flap and box): 13¾" x 21¾" (35 x 55 cm)

Batting (for flap and box): 13¾" x 21¾" (35 x 55 cm)

Fusible interfacing (for flap and box): 13¾" x 21¾" (35 x 55 cm)

Plastic board: 11¾" x 17¾" (30 x 45 cm)

Button: One ⅜" x ¾" (0.9 x 2 cm) button

Embroidery floss: 6-strand embroidery floss

Thread: Candlewicking thread

Cut the fabric.

Trace and cut out the templates on Pattern Sheet D. Using the templates, cut out the appliqué pieces, appliqué base, flap, flap foundation, short and long sides, and bottom. The box foundation fabric, box batting, and box lining should each be cut out in one piece once the bottom and sides of the box have been attached. Cut out the following piece, which does not have a template, according to the measurements below:

✂ Bias strip (for flap binding): One 1½" X 23½" (3.5 x 60 cm) bias strip

*The numbers on the appliqué pieces represent fabrics. Use the same fabric for templates with the same number.

- -

A. Make the flap and sides.

① Appliqué the flap and sides (both short and long sides).

② Embroider the flap and sides (refer to page 95 for embroidery instructions).

③ Layer the flap, batting, and foundation fabric. On the sides, draw quilting lines at a 45-degree angle, about ⅛" (0.3 cm) apart and quilt. Quilt around the scalloped edge using a ¹⁄₁₆" (0.2 cm) seam allowance.

③ Quilting lines at a 45-degree angle about ⅛" (0.3 cm) apart
Quilting
Main fabric (right side)
Hemstitch
Appliqué base fabric
Batting
Foundation fabric
Flap (right side)
Batting
Foundation fabric (wrong side)
① Appliqué base fabric (right side)
¼" (0.6 cm)
¹⁄₁₆" (0.2 cm) seam allowance
② Colonial knot stitch (use candlewicking thread)

B. Attach the bottom and sides.

① With right sides together, sew the sides to the bottom to create the box, starting and stopping at the marks, as shown in the diagram. Press the seam allowances towards the bottom.
② Layer the box, batting, and foundation fabric.
③ For the sides, draw quilting lines at a 45-degree angle, about ¼" (0.6 cm) apart and quilt. For the bottom, free-hand quilt, as shown in the diagram.

*Remember to cut out the box foundation fabric, box batting, and box lining, each in one piece.

C. Attach the lining.

① Press fusible interfacing to the wrong side of the lining. With right sides together, layer the lining and box.
② Sew from mark to mark, leaving all four sides open.
③ Make clips in the seam allowance.
④ Measure the sides and bottom and cut plastic boards accordingly.

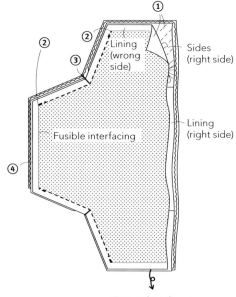

Turn right side out.

D. Insert the plastic boards.

① On the right side, topstitch along three sides at the bottom.
② Insert the bottom plastic board through the open side.
③ Topstitch the open side closed at the bottom.
④ Insert the side plastic boards through each open side.
 You may need to bend the plastic board slightly.
⑤ Fold the seam allowances and hemstitch the open sides closed.

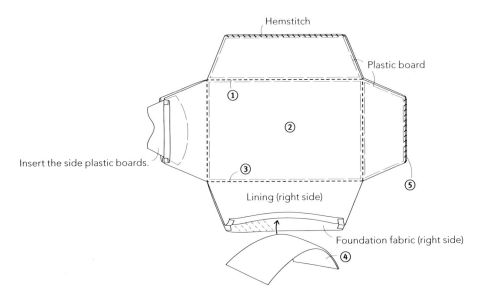

Hemstitch

Plastic board

Insert the side plastic boards.

Lining (right side)

Foundation fabric (right side)

E. Attach the sides.

① Fold the sides into place and attach
 using a whipstitch.

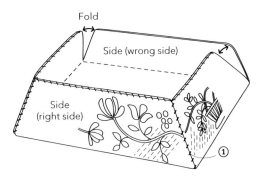

Fold

Side (wrong side)

Side
(right side)

F. Finish the flap.

① Press fusible interfacing to the wrong side of the flap lining. Layer the flap and the flap lining.
② Topstitch the flap and flap lining together around three sides.
③ Insert the flap plastic board through the open side. Topstitch the open side closed.
④ With right sides together, sew the bias strip to the flap using a ¼" (0.6 cm) seam allowance.
⑤ Wrap the bias strip around the seam allowances and hemstitch to the flap lining.

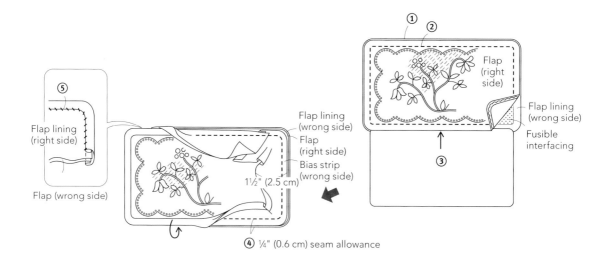

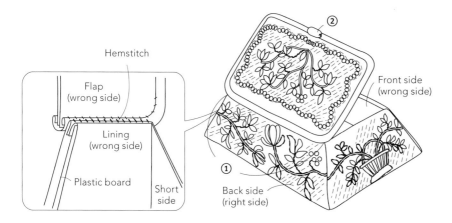

G. Attach the flap and button to the box.

① Attach the flap to the back side of the box by hemstitching the bias strip to the lining on the inside of the box.
② Sew the button to the flap at the front.

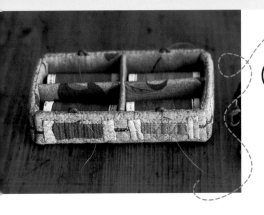

㉓ Thread Case with Spool Appliqué

Photo on page 39

Materials

Appliqué fabric: Assorted scraps

Side fabric: 8" x 8" (20 x 20 cm)

Bottom fabric: 4" x 8" (10 x 20 cm)

Lining fabric (for case lining, foundation fabric, and dividers): 11¾" x 15¾" (30 x 40 cm)

Batting: 8" x 9¾" (20 x 25 cm)

Fusible interfacing (for case lining and dividers): 11¾" x 11¾" (30 x 30 cm)

Cording: 4¾" (12 cm) of thin waxed cording

Plastic board: 8" x 11¾" (20 x 30 cm)

Cut the fabric.

Trace and cut out the templates on Pattern Sheet D. Using the templates, cut out the appliqué pieces, bottom, short sides, and long sides. The case lining should be cut out in one piece once the bottom and sides of the case have been attached. Cut out the following pieces, which do not have templates, according to the measurements below:

✂ Lengthwise divider: One X x 2Z + seam allowances piece

✂ Sideways divider: Two Y x 2X + seam allowances pieces

--

A. Make the case.

① Appliqué the sides. With right sides together, sew the sides to the bottom to create the case.

② Layer the case, batting, and foundation fabric.

③ Draw quilting lines at 45-degree angles, about ⅜" (1 cm) apart and quilt. Free-hand quilt the appliqué pieces and bottom, as shown in the diagram.

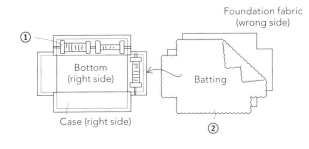

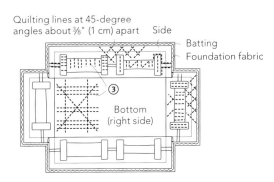

B. Attach the lining and insert the plastic boards.

① Press fusible interfacing to the wrong side of the lining. With right sides together, layer the lining and the case. Sew from mark to mark on each corner, leaving all four sides open. Make clips in the seam allowances and turn right side out.

② On the right side, topstitch along three sides at the bottom. Measure the sides and bottom and cut plastic boards accordingly.

③ Insert the bottom plastic board through the open side. Topstitch the open side closed at the bottom.

④ Insert the side plastic boards through each open side.

⑤ For the short sides, fold the seam allowances and hemstitch the open sides closed. For each long side, insert two 1¼" (3 cm) long waxed cording loops, as shown in the diagram, then fold in the seam allowances and hemstitch the opening closed.

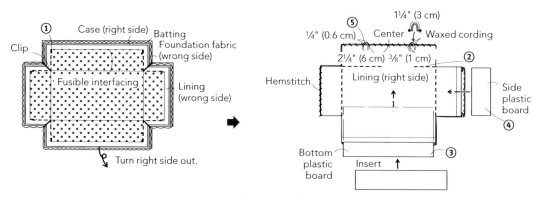

* Remember to cut out the case lining in one piece.

C. Make the dividers.

① Press fusible interfacing to the wrong side of each divider piece. With right sides together, fold each divider piece in half, as shown in the diagram, and sew along the two short sides.

② Turn the dividers right side out. Insert plastic boards through the open sides and hemstitch the open sides closed. You should have one lengthwise divider and two sideways dividers.

③ Position the lengthwise divider and hemstitch both sides to the lining.

④ Position the two sideways dividers and hemstitch both sides to the lining.

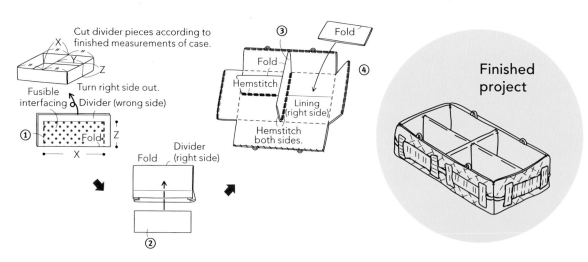

Finished project

㉔ Measure Case with Triangle Patchwork

Photo on page 39

Materials

Appliqué fabric: Assorted scraps

Side fabric: 4" x 8" (10 x 20 cm)

Gusset fabric: 1¼" x 11¾" (3 x 30 cm)

Lining fabric: 6¼" x 9¾" (16 x 25 cm)

Batting: 6¼" x 8" (16 x 20 cm)

Decorative fabric: Small scrap

Cording: 3" (7.5 cm) of thin waxed cording

Snap hook: One metal snap hook

Beads: One small and one large bead

Cut the fabric.

Trace and cut out the templates on Pattern Sheet D. Using the templates, cut out the appliqué pieces, sides, and side linings. Cut out the following pieces, which do not have templates, according to the measurements below:

✂ Gusset A: One 1¼" x 8½" (2.7 x 21.2 cm) piece

✂ Gusset A lining: One 1¼" x 8½" (2.7 x 21.2 cm) piece

✂ Gusset B: One 1¼" x 1½" (2.7 x 3.2 cm) piece

✂ Gusset B lining: One 1¼" x 1½" (2.7 x 3.2 cm) piece

✂ Decorative fabric piece: One ⅜" x ½" (0.8 x 1.2 cm) piece

A. Make the case sides.

① Appliqué the case sides. Use the pattern to make one set of triangles, then flip the pattern over and trace again to make a second set of triangles that are a mirror image.

② Mark the gusset placements

③ Divide each case side into six equal sections and draw quilting lines, as shown in the diagram.

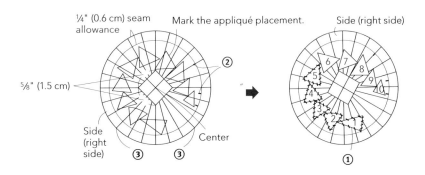

¼" (0.6 cm) seam allowance

Mark the appliqué placement.

Side (right side)

⅝" (1.5 cm)

Side (right side)

Center

③ ③

①

B. Quilt each case side.

① With right sides together, layer the batting, case side, and lining.
② Sew, leaving a 1¼" (3 cm) opening to turn right side out.
③ Trim excess batting and turn right side out.
④ Hemstitch the opening closed.
⑤ Quilt a curved line that travels through the center of each triangle. Stitch in the ditch around the triangles. Quilt a square in the center. Follow the quilting lines to create a radial pattern.

C. Make the gussets.

① With right sides together, layer gusset A lining, gusset A, and batting. Sew, leaving a 1¼" (3 cm) opening to turn right side out. Trim excess batting and turn right side out.
② Hemstitch the opening closed.
③ Quilt horizontal lines, as shown in the diagram.
④ To make gusset B, follow Steps 1-3, making sure to insert a 1½" (3.5 cm) long loop of waxed cording between the layers before sewing.

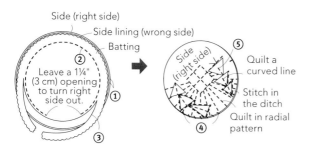

Side (right side)
Side lining (wrong side)
Batting

② Leave a 1¼" (3 cm) opening to turn right side out.
①
③

Side (right side)
⑤ Quilt a curved line
Stitch in the ditch
Quilt in radial pattern
④

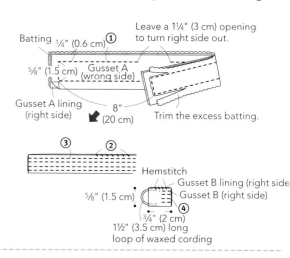

Leave a 1¼" (3 cm) opening to turn right side out.
Batting ¼" (0.6 cm) ①
⅝" (1.5 cm) Gusset A (wrong side)
Gusset A lining (right side)
8" (20 cm)
Trim the excess batting.

③ ②
Hemstitch
⅝" (1.5 cm)
Gusset B lining (right side)
Gusset B (right side)
④
¾" (2 cm)
1½" (3.5 cm) long loop of waxed cording

D. Attach the gussets.

① Align gusset A with the marks and sew using a whipstitch. Leave the remaining portion of gusset A unattached.
② Align gusset B with the marks and sew using a whipstitch.

E. Insert the tape measure and finish.

① Insert the tape measure into the case. Thread the tape through gusset B. Thread the beads onto a small piece of waxed cording and knot the ends. Overlap the cording with the tip of the tape measure. Wrap the tip of the tape measure and cording with the decorative fabric and hemstitch.
② Thread the snap hook onto the unattached end of gusset A. Fold the end of gusset A and hemstitch.

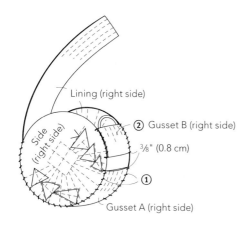

Lining (right side)
② Gusset B (right side)
⅜" (0.8 cm)
①
Side (right side)
Gusset A (right side)

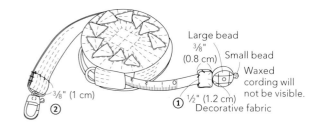

Large bead
⅜" (0.8 cm)
Small bead
Waxed cording will not be visible.
⅜" (1 cm)
② ①
½" (1.2 cm)
Decorative fabric

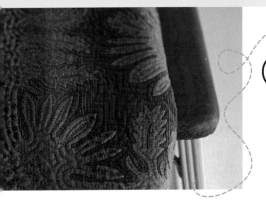

㉕ Hawaiian Quilt Tapestry

Photos on pages 40-41

Materials

Appliqué fabric:
27½" x 27½" (70 x 70 cm)

Top fabric: 27½" x 27½" (70 x 70 cm)

Backing fabric (for backing
and binding): 43¼" x 51¼"
(110 x 130 cm)

Batting: 31½" x 31½" (80 x 80 cm)

Cut the fabric.

Trace and cut out the quilt template on Pattern Sheet D. Cut out the following pieces, which do not have templates, according to the measurements below:

✂ Binding bias strips: 1" (2.5 cm) wide bias strips

A. Appliqué the quilt top.

① Fold the appliqué fabric into eighths, as shown on page 138. Baste the layers together.
② Position the template on top of the appliqué fabric.
③ Transfer the appliqué design to the appliqué fabric.
④ Cut away the excess fabric, leaving only the floral appliqué design. Make sure to cut through all layers. *Note*: Seam allowance is already included in the appliqué design.
⑤ Fold the top fabric into eighths and press with the iron to crease.
⑥ Remove the basting and unfold the appliqué fabric and the top fabric. Position the cut appliqué fabric on top of the top fabric and baste around the edges. Fold the ⅛" (0.3 cm) seam allowance of the appliqué fabric under and hemstitch (refer to page 111 for reverse appliqué instructions).

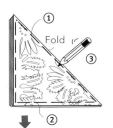

① Fold
③
②

④ Cut away the excess
appliqué fabric.

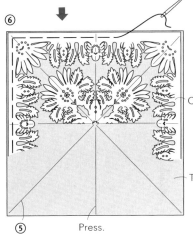

⑥

Cut appliqué fabric

Top fabric (right side)

⑤ Press.

How to fold the fabric into eighths

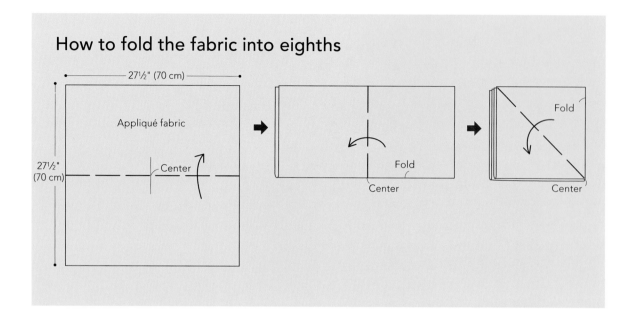

27½" (70 cm)

27½"
(70 cm)

Appliqué fabric

Center

Fold

Center

Fold

Center

B. Quilt and bind the quilt.

① Layer the quilt top, batting, and backing. Quilt around the appliqué design.
② With right sides together, sew the 1" (2.5 cm) wide bias strips to the quilt top using a
 ¼" (0.6 cm) seam allowance.
③ Trim the excess batting.
④ Fold the bias strip so it is not visible from the right side of the quilt and hemstitch to the backing.

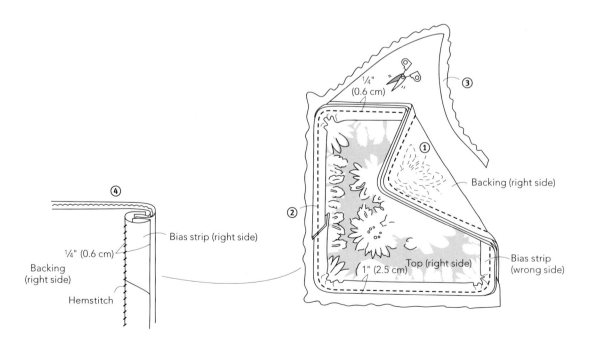

¼"
(0.6 cm)

③

①

Backing (right side)

②

¼" (0.6 cm)

Bias strip (right side)

Backing
(right side)

Hemstitch

1" (2.5 cm)

Top (right side)

Bias strip
(wrong side)

④

A. Appliqué the quilt top.

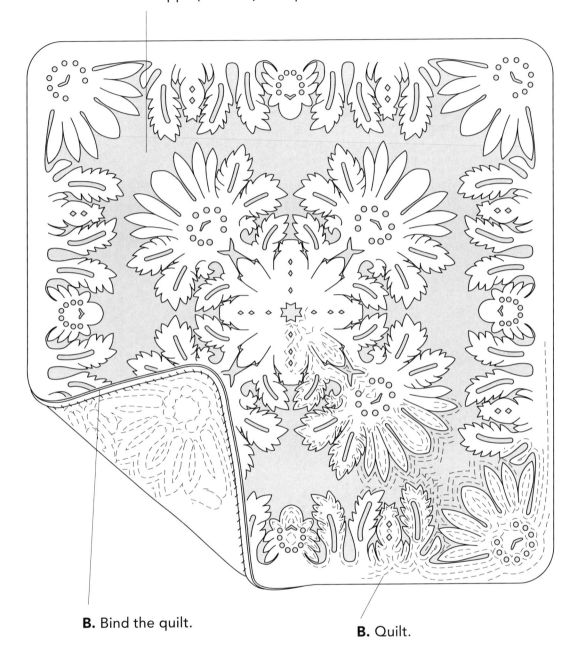

B. Bind the quilt.

B. Quilt.

㉖ Cushions with Circles

Photos on pages 42-43

Materials (for one cushion)

Patchwork fabric (for circle, base, and lattice pieces): Assorted scraps

Foundation fabric:
17¾" x 17¾" (45 x 45 cm)

Pillow form fabric:
17¾" x 35½" (45 x 90 cm)

Backing fabric:
17¾" x 17¾" (45 x 45 cm)

Accent fabric (for bias strips and strings): 23½" x 23½" (60 x 60 cm)

Batting: 17¾" x 17¾" (45 x 45 cm)

Stuffing: Polyester/cotton stuffing

Cut the fabric.

Trace and cut out the templates on Pattern Sheet D for selected cushion design. Using the templates, cut out the circle, base, and lattice pieces, foundation, and backing. Cut out the following pieces, which do not have templates, according to the measurements below:

✂ Pillow form pieces: Two pieces slightly smaller than the backing

✂ Bias strips: 1½" (3.5 cm) wide bias strips

✂ String pieces: Two 2" x 21¼" (5 x 54 cm) pieces

*The numbers on the circle pieces represent fabrics. Use the same fabric for templates with the same number.

- -

A. Make the pillow top and pillow form.

① For either design, sew the patchwork pieces together to make four circles. Appliqué the circles to the base pieces. Sew the base pieces to the lattice pieces to make the pillow top.

② Layer the top, batting, and foundation fabric. Quilt as desired.

③ Make the pillow form: With right sides together, sew two pieces of pillow form fabric leaving a small opening. The pillow form should be slightly smaller than the pillow top. Fill the pillow form with stuffing and hemstitch the opening closed.

B. Sew the pillow together.

① With wrong sides together, layer the pillow top, pillow form, and backing.
 Sew around all four sides.
② With right sides together, sew the bias strip to the pillow top.
③ Wrap the bias strip around the seam allowances and hemstitch to the backing.

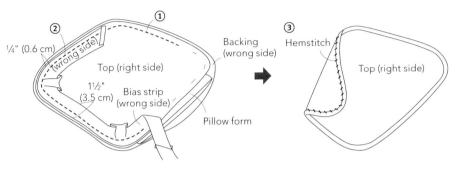

¼" (0.6 cm)

② (wrong side)

①

Top (right side)

1½" (3.5 cm)

Bias strip (wrong side)

Pillow form

Backing (wrong side)

③ Hemstitch

Top (right side)

C. Attach the strings.

① Fold the string pieces in half widthwise with right sides together and sew,
 leaving an opening. Turn right side out.
② Hemstitch the opening closed. Topstitch using a ⅛" (0.3 cm) seam allowance.
③ Fold each string in half lengthwise and tack to the pillow on the backing.

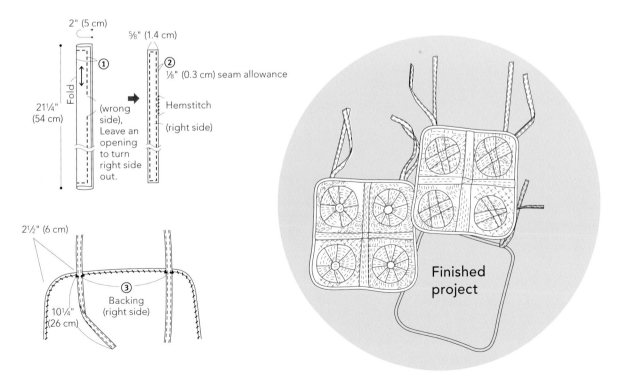

2" (5 cm)

⅝" (1.4 cm)

①

② ⅛" (0.3 cm) seam allowance

21¼" (54 cm)

Fold

(wrong side), Leave an opening to turn right side out.

Hemstitch

(right side)

2½" (6 cm)

③

Backing (right side)

10¼" (26 cm)

Finished project

㉗ Apron with Appliqué

Photos on pages 44-45

Materials

Appliqué fabric: Assorted scraps

Apron fabric: 23½" x 43¼" (60 x 110 cm)

Pocket fabric (for pockets A-D): 8" x 11¾" (20 x 30 cm) each

Foundation fabric: 8" x 43¼" (20 x 110 cm)

Accent fabric (for decorative ends): Small scrap

Bias strip fabric A (for binding A): 1½" x 39½" (3.5 x 100 cm) bias strip

Bias strip fabric B (for binding B): 1½" x 39½" (3.5 x 100 cm) bias strip

Linen tape: 94½" (240 cm) of 1" (2.5 cm) wide linen tape

Cut the fabric.

Trace and cut out the templates on Pattern Sheet D. Using the templates, cut out pocket applique pieces 1-28. Cut out the following pieces, which do not have templates, according to the measurements below:

✂ Pocket pieces A & D: 6¾" x 10¼" (17 x 26 cm) each

✂ Pocket pieces B & C: 6¾" x 11" (17 x 27 cm) each

✂ Foundation fabric piece: One 6¾" x 39½" (17 x 100 cm) piece

✂ Binding A: One 1½" x 39½" (3.5 x 100 cm) bias strip

✂ Apron: One 20" x 37¾" (51 x 96 cm) piece

✂ Binding B: Two 1½" x 19¾" (3.5 x 50 cm) bias strips

✂ Decorative ends: Four 1½" x 1½" (4 x 4 cm) pieces

Layout Diagram

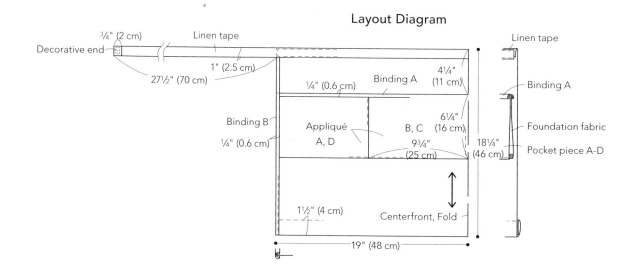

A. Make the pockets.

① Appliqué pocket pieces A-D.
② With right sides together, sew pocket pieces A-D together along short sides.
 Press seam allowances in one direction.
③ With right sides together, sew the pocket pieces to the foundation fabric.
④ Fold the foundation fabric so it is not visible from the right side and press with the iron.
⑤ With right sides together, sew binding A to the pocket pieces using a ¼" (0.6 cm)
 seam allowance.
⑥ Wrap the binding around the seam allowances and hemstitch to the foundation fabric.

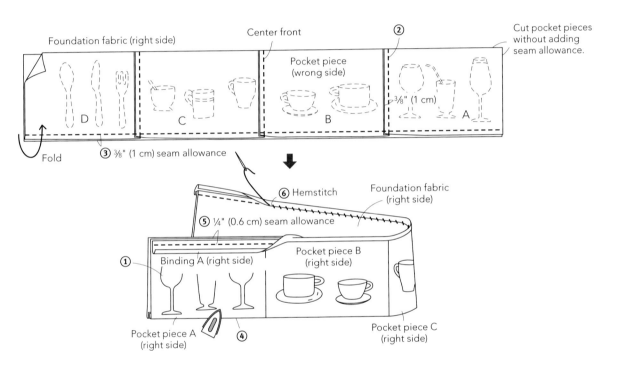

B. Attach the pocket piece and finish the bottom and sides.

① Position the pocket piece on top of the apron, as shown in the diagram, and baste along the sides.

② Topstitch the pocket piece to the apron along the bottom and one side of each pocket piece A-D using a ¹⁄₃₂" (0.1 cm) seam allowance.

③ Fold the top of the apron over ¾" (2 cm) to the right side and baste.

④ Fold the bottom of the apron over ¾" (2 cm) twice and topstitch along the edge.

⑤ With right sides together, sew a binding B piece to each apron side using a ¼" (0.6 cm) seam allowance. Make sure to start and stop sewing ⅜" (1 cm) from the top and bottom of binding B. Fold the top and bottom edges of binding B in, then wrap the binding around the seam allowance. Topstitch the binding along the edge.

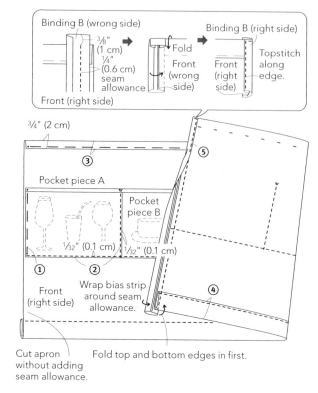

C. Attach the tape and finish the top edge.

① With right sides together, sew two decorative end pieces together along three sides. Trim seam allowance to ¼" (0.6 cm). Turn right side out and fold the seam allowance in. Insert the tape into the opening. Topstitch the decorative end, stitching through the tape.

② Position the tape on top of the apron and topstitch, as shown in the diagram.

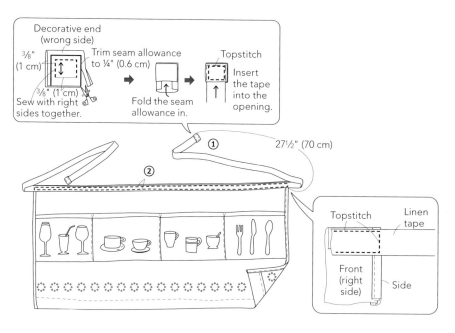

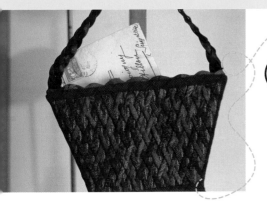

28 Basket Wall Pocket

Photo on page 46

Materials

Appliqué fabric (for bias strips):
 Assorted scraps

Scallop fabric: 8"x 8" (20 x 20 cm)

Bias fabric (for binding):
 8" x 8" (20 x 20 cm)

Back fabric: 8" x 9¾" (20 x 25 cm)

Top front fabric: 6" x 9¾" (15 x 25 cm)

Bottom front fabric: 4" x 8"
 (10 x 20 cm)

Lining fabric: 9¾" x 19¾"
 (25 x 50 cm)

Batting: 9¾" x 19¾" (25 x 50 cm)

Leather trim:
 One 19¾" (50 cm) long piece
 of ¼" (0.6 cm) wide of brown
 leather trim
 One 19¾" (50 cm) long piece
 of ¼" (0.6 cm) wide of black
 leather trim
 Two 19¾" (50 cm) long pieces
 of ¼" (0.6 cm) wide of moss
 green leather trim

Plastic board: 7" x 8¼" (18 x 21 cm)

Cut the fabric.

Trace and cut out the templates on Pattern Sheet D. Using the templates, cut out the front (top and bottom), back, front lining, back lining, bias pieces, and scallop pieces. Cut out the following pieces, which do not have templates, according to the measurements below:

✂ Bias strips (for appliqué): Thirty ¾" x 6¼" (2 x 16 cm) bias strips

- -

A. Make bias strips for appliqué.

① Fold a ¾" (2 cm) wide bias strip in half widthwise with right sides together and sew using a ¼" (0.6 cm) seam allowance. Trim the seam allowance to ⅛" (0.3 cm) and turn right side out. Center the seam and press. Make thirty ⅜" x 6¼" (1 x 16 cm) bias strips.

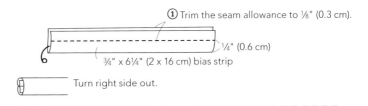

① Trim the seam allowance to ⅛" (0.3 cm).

¼" (0.6 cm)

¾" x 6¼" (2 x 16 cm) bias strip

Turn right side out.

- -

B. Appliqué the bias strips to the top front piece.

① Pin the bias strips to the top front piece and baste at the top. Weave the bias strips and baste to secure.
② Hemstitch the bias strips to the top front piece along both long edges.

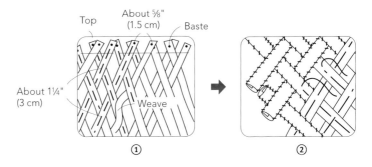

Top

About ⅝" (1.5 cm)

Baste

About 1¼" (3 cm)

Weave

①

②

C. Appliqué the bias strips to the bottom front piece and attach the bias pieces to the sides.

① Appliqué the remaining ⅜" (1 cm) wide bias strips to the bottom front piece.
② With right sides together, sew the bias pieces to each side of the top and bottom front.

Bias pieces

②

①

D. Sew the bag front together.

① Sandwich the middle bias piece between the top and bottom front pieces with right sides together and sew.
② Fold the bias piece to the finished size and hemstitch.
③ With right sides together, sew bias pieces to the top and bottom of the front.

①

Bias piece (wrong side)

(right side)

(wrong side)

Attach bias pieces to the top and bottom.

Bias piece (right side)

Bias piece (right side)

Bias piece (right side)

③

③

② Hemstitch

E. Make the scallop.

① With right sides together, layer the batting and two scallop pieces. Sew along the top and two sides. Make clips in the seam allowance, trim excess batting, and turn right side out.

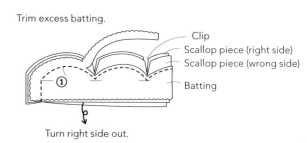

Trim excess batting.

Clip
Scallop piece (right side)
Scallop piece (wrong side)

①

Batting

Turn right side out.

F. Finish the front and quilt.

① Align the front and front lining with right
sides together and the scallop piece
sandwiched in between. Sew, leaving a 2"
(5 cm) opening.

② Turn right side out and hemstitch the
opening closed.

③ Stitch in the ditch around the bias strips.

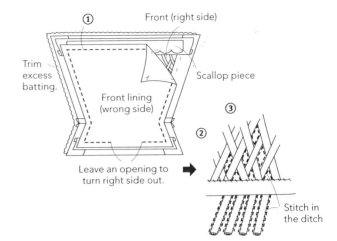

G. Make the handle and back.

① Baste four pieces of leather trim together at the top and braid into a 13" (33 cm) long handle.

② Layer the back and batting. Draw quilting lines at a 45-degree angle, about ⅜" (1 cm) apart
and quilt.

③ Align the back, back lining, and batting and sandwich the handle in between the back and
the back lining. Sew, leaving a 4" (10 cm) opening, and turn right side out.

④ Insert plastic board into the opening and hemstitch the opening closed.

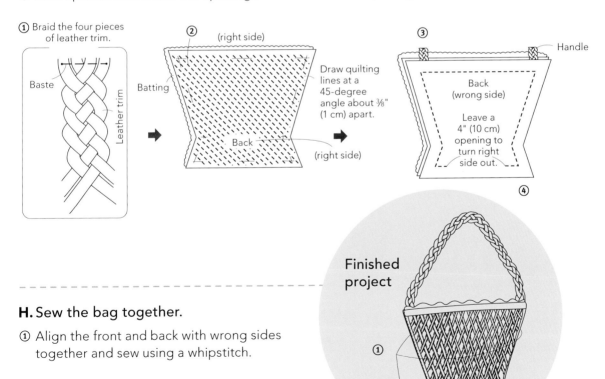

H. Sew the bag together.

① Align the front and back with wrong sides
together and sew using a whipstitch.

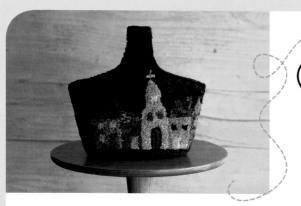

㉙ Hooked Rug Bag

Photo on page 47

Materials

Wool (for rug hooking):
 3¼" x 11¾" (8 x 30 cm) pieces
 for each color

Canvas: 15¾" x 31½" (40 x 80 cm) of
 6 grid/1 cm rug hooking canvas

Bias strip fabric (for piping):
 13¾" x 13¾" (35 x 35 cm)

Lining fabric: 15¾" x 31½"
 (40 x 80 cm)

Batting: 15¾" x 31½" (40 x 80 cm)

Piping cord: 39½" (100 cm) of ⅛"
 (0.3 cm) thick piping cord

Cut the fabric.

Trace and cut out the templates on Pattern Sheet D. Using the templates cut out the bag sides and bottom from the canvas, plus the bag lining and bottom lining. Cut out the following pieces, which do not have templates, according to the measurements below:

✂ Bias strips (for piping): 1" (2.5 cm) wide bias strips

--

A. Prepare the canvas.

① Transfer the design to the canvas.
② Machine stitch around the design using a ⅜" (1 cm) seam allowance. This will prevent the canvas from fraying.

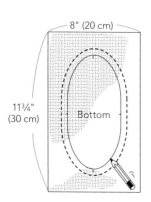

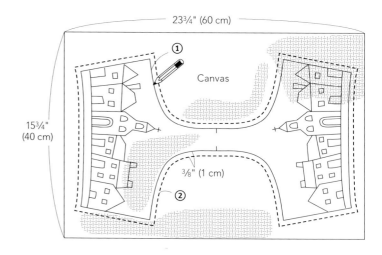

B. Make the wool strips.

① Use a rotary cutter to make ¼" x 11¾" (0.6 x 30 cm) wool strips.

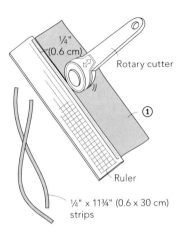

¼"
(0.6 cm)

Rotary cutter

①

Ruler

¼" x 11¾" (0.6 x 30 cm) strips

C. Hook the bag sides and bottom.

① Working from the right side of the canvas, insert the hook to the wrong side through an empty grid.
② Hold a wool strip in your left hand on the wrong side of the canvas. Hook the strip and pull it to the right side of the canvas through the empty grid. Make a ¼" (0.6 cm) high loop. Make sure to leave a ¾" (2 cm) long tail on the wrong side of the canvas when starting.
③ Continue working, leaving one or two empty grid boxes between each loop. In order to ensure a nice finish, make sure loops are even in height. When a strip runs out, pull the end to the wrong side of the canvas. Insert a new strip in the same grid box and continue working.

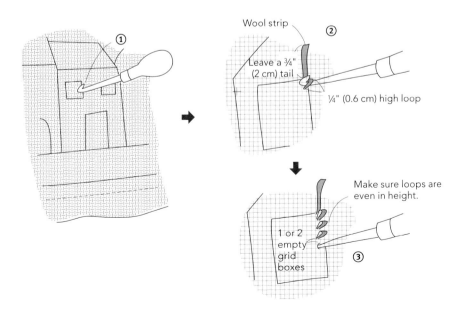

①

Wool strip

②

Leave a ¾" (2 cm) tail

¼" (0.6 cm) high loop

Make sure loops are even in height.

1 or 2 empty grid boxes

③

D. Iron the bag sides and bottom.

① Once the sides and bottom are complete, sandwich the canvas between two damp towels with the right side facing up. Gently steam the work.

Bag (right side)

Ironing board

Damp towel

Damp towel

①

E. Finish the edges of the bag sides.

① Trim the excess canvas along the machine stitching.
②. Fold the canvas seam allowance to the wrong side and hemstitch. Make clips in the curved seam allowance if necessary.
③ Make the piping cord and attach it to the curved edges of the bag sides (refer to page 102 for piping cord instructions). About ¼" (0.6 cm) of the piping should be visible from the right side of the work.

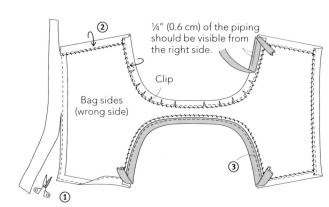

②

¼" (0.6 cm) of the piping should be visible from the right side.

Clip

Bag sides (wrong side)

③

①

F. Attach the lining.

① Press fusible interfacing to the wrong side of the bag lining.
② Fold in the lining seam allowance. Make clips in the curved seam allowance if necessary.
③ Hemstitch the lining to the bag.

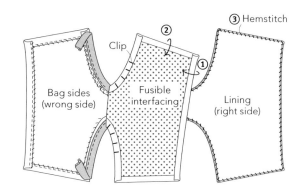

③ Hemstitch

②

Clip

①

Bag sides (wrong side)

Fusible interfacing

Lining (right side)

G. Sew the bag together.

① Sew the bag together at the sides using a whipstitch on both the inside and outside of the bag.

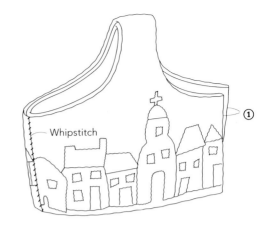

Whipstitch

①

H. Make the bag bottom.

① Press fusible interfacing to the wrong side of the bottom lining. Fold in the bottom lining and bag bottom seam allowances. Make clips in the seam allowances if necessary. Hemstitch the bottom lining to the bag bottom.

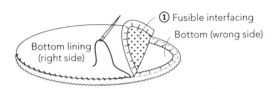

① Fusible interfacing

Bottom (wrong side)

Bottom lining (right side)

I. Attach the bottom to the bag.

① Sew the bottom to the bag using a whipstitch on both the inside and outside of the bag.

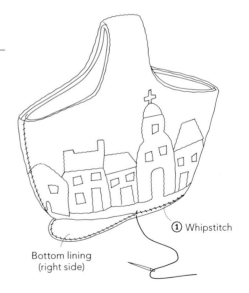

① Whipstitch

Bottom lining (right side)

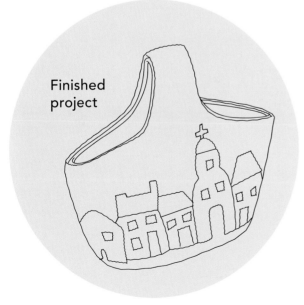

Finished project

Resources

Quilt Party
www.shop.quilt.co.jp/en
Yoko Saito's website offering international shipping on fabrics, kits, and notions

Lecien
www.lecienusa.com
Yoko Saito's fabric line is distributed to Lecien, USA and can be found at your local quilt shop—check Lecien's website for a list of suppliers

Pinwheels Trading Corp.
www.pinwheelstrading.com
U.S. distributor of Daiwabo taupe fabrics, popular among Japanese quilters

Quilted Threads
www.quiltedthreads.com
Offers a wide selection of Yoko Saito fabric and Daiwabo fabric

U-Handbag
www.u-handbag.com
Provides handbag-making supplies for the home sewist

About the Author

In 1985, Yoko Saito opened Quilt Party, a store and workshop where she earned a reputation for precise needlework and established her signature style involving the use of earth tones. In addition to making regular television and magazine appearances in Japan, Yoko Saito holds international quilting exhibitions and workshops. In 2008, she celebrated 30 years of quilting with the Yoko Saito Quilt Exhibition at the Matsuya department store in Ginza, Tokyo. Yoko Saito designs her own fabric line and is the author of multiple books in Japan.